IMAGES
of Aviation

SEATTLE'S
COMMERCIAL AVIATION
1908–1941

IMAGES
of Aviation

SEATTLE'S
COMMERCIAL AVIATION
1908–1941

Ed Davies and Steve Ellis
Foreword by Bill Boeing Jr.

ARCADIA
PUBLISHING

Copyright © 2009 by Ed Davies and Steve Ellis
ISBN 978-0-7385-7101-0

Published by Arcadia Publishing
Charleston SC, Chicago IL, Portsmouth NH, San Francisco CA

Printed in the United States of America

Library of Congress Control Number: 2009920420

For all general information contact Arcadia Publishing at:
Telephone 843-853-2070
Fax 843-853-0044
E-mail sales@arcadiapublishing.com
For customer service and orders:
Toll-Free 1-888-313-2665

Visit us on the Internet at www.arcadiapublishing.com

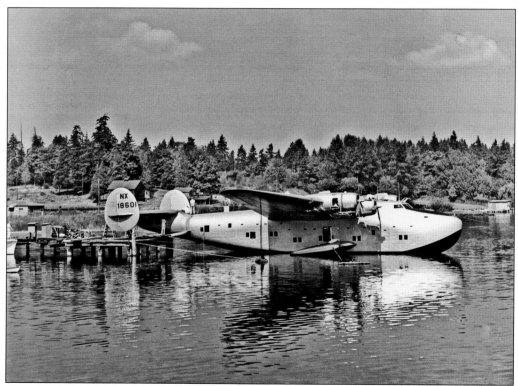

To enhance stability, twin rudders have replaced the Boeing 314 Clipper's original single tail in this September 1938 photograph at Matthews Beach on Lake Washington. Following flight tests, a third central vertical stabilizer was added to create the empennage arrangement that became standard for all 314 flying boats. (Ed Davies Collection.)

CONTENTS

ACKNOWLEDGMENTS

The authors very much appreciate the support and assistance from the following individuals and institutions: Dan Hagedorn, senior curator for the Museum of Flight; museum staff, including Katherine Williams, Amy Heidrick, Meredith Downs, P. J. Mueller, Janice Baker, Kent Carter, and Scott Linholm; the Museum of History and Industry's Carolyn Marr; the University of Washington's Special Collections' Nicolette Bromberg; King County Archives' Rebecca Pritzer; the Boeing Company's Mike Lombardi, Tom Lubbesmeyer, and Mary Kane; the Alaska Historical Aviation Institute's Ted Spencer; aviation historian William Larkins; and local enthusiasts Dennis Parks, Ted Young, Ken Blais, Bob Dempster, John Litz, Vic Seely, Tim Detweiler, Kevin Fitz, Cory Graff, and Julie Albright. The guidance provided by Arcadia Publishing acquisitions editor Sarah Higginbotham was invaluable.

Photograph credits are noted in captions. The following is a key to those that are abbreviated:

BA	Boeing Archives
WLC	William Larkins Collection
EDC	Ed Davies Collection
ED	Ed Davies
KCA	King County (WA) Archives
MOHAI	The Museum of History and Industry, Seattle
MOHAI-P	The Museum of History and Industry, Seattle's PEMCO Webster and Stevens Collection
MOHAI-PI	The Museum of History and Industry, Seattle's *Post-Intelligencer* Collection
RWE	Robert W. Ellis
TSC	Ted Spencer Collection
TMOF	The Museum of Flight, Seattle
VSC	Vic Seely Collection

FOREWORD

In January 1910, my father hoped to obtain his first airplane ride in Los Angeles at an international air show. Unsuccessful, more than four years would pass before he took his first hop in a Curtiss seaplane.

Meanwhile, Seattle teenager Tom Hamilton was attempting to sell airplanes and gliders by advertising in national aviation magazines. Father was aware of the efforts of Hamilton and other aviation enthusiasts in the Seattle area. Their accomplishments were periodically reported in the local press and national publications.

In 1915, father purchased an airplane from Glenn Martin and learned to fly. Father, with the help of U.S. Navy lieutenant Conrad Westervelt, designed and built his first plane. He made the first flight in June 1916. He incorporated Pacific Aero Products, which grew into the company that still bears his name and today dominates commercial airliner design and production in the United States.

In May 1918, the U.S. Post Office Department inaugurated a regular airmail service between Washington, D.C., Philadelphia, and New York. By September 1920, post office planes were flying coast to coast. In February 1925, the U.S. Congress passed the Kelly Act, the "birth certificate of the commercial airplane industry" that transferred carriage of mail from the post office to private industry. It allowed various routes selected by the post office to be awarded to contractors chosen by a sealed bidding process. In addition to the mail, passengers and freight could be carried. The winning operators included Varney Air Lines, Pacific Air Transport, Boeing Air Transport, and National Air Transport; all eventually merged into the Boeing Group of Seattle and eventually became today's United Airlines.

World War I ended, leaving a surplus of military planes and equipment. Father and other aviation enthusiasts noted Alaska and its needs for transportation. By the 1930s, the airplane would help meet Alaska's transportation needs. Those operators would rely on Seattle for support.

In *Seattle's Commercial Aviation: 1908–1941*, authors Ed Davies, and Steve Ellis use photographs from various sources to tell the story of how pioneers, entrepreneurs, airlines, and the Boeing Airplane Company developed commercial aviation in Seattle.

—Bill Boeing Jr.

INTRODUCTION

In 1908, Guy Mecklem demonstrated powered flight in Seattle by flying his lighter-than-air dirigible. In March 1910, Charles K. Hamilton introduced heavier-than-air flight when he performed in his Curtiss pusher. Just 31 years later, on the eve of the United States' entry into World War I, Boeing-built airliners like the Model 307 Stratoliner and the Model 314 Clipper flying boat were crossing oceans and continents while passengers experienced a unique level of luxury.

In between, commercial aviation in the Seattle area proceeded with starts and stops. Innovative, curious, and enterprising individuals with their eyes on the sky came and went. Some early pioneers—Tom Hamilton, Herb Munter, and William Boeing—persevered. Others failed to achieve their goals and lost money or interest or both.

Between 1910 and 1915, dozens of aviation enthusiasts in the Seattle area attempted to fly. Perhaps it was the Wright Corporation's attempt to corner aircraft patents that discouraged innovation and entrepreneurship, but the interest in commercial aviation declined, especially after the United States entered World War I in April 1917. Early in 1918, Pres. Woodrow Wilson banned private aviation. With the ban lifted in February 1919, William Boeing and Eddie Hubbard completed their historic mail flight from Vancouver, British Columbia, to Seattle in March. By May, Hubbard operated a charter service from the original Boeing hangar on Lake Union.

Despite the end of the war, commercial flying stagnated. Surplus wartime aircraft and engines glutted the market. Furthermore, Seattle lacked an adequate commercial airfield until Boeing Field opened in July 1928. Boeing Field and new aircraft powered by efficient air-cooled radial engines changed everything. The little guy could successfully operate a flying school or charter service. William Boeing embraced the profit-making opportunity provided by the U.S. Congress to fly the mail commercially. His company built airliners and ran airlines.

Aviation was unable to escape the Great Depression, which crushed businesses everywhere in the 1930s. One exception, however, was Alaska, where dependence on the airplane increased as the technology improved. Many Seattle-based flyers found success to the north, and Boeing Field and Lake Union frequently played host to their aircraft.

One

THE EARLY BIRDS

Like people everywhere, the residents of Seattle and its environs found manned flight fascinating. A hot-air balloon ascent followed by a parachute jump occurred over Seattle as early as 1889. Guy Mecklem and J. C. "Bud" Mars were the first to demonstrate powered flight by piloting dirigibles over Seattle.

Of course, Charles K. Hamilton, sponsored by Glenn Curtiss, brought heavier-than-air flight to Seattle in March 1910 with his legendary exhibition at the Meadows. Residents took the train to this racetrack, hotel, and amusement center near where the Museum of Flight is today situated at the southwest corner of Boeing Field. Hamilton's visit inspired an untold number of boys and men to look to the skies for their future. Some would be more successful than others. Individuals like George Takasou, Tom Hamilton, Herb Munter, and William Boeing would go on to careers in aviation. Others like Eugene Romano would fade away.

Between 1911 and 1915, Seattle's neophyte aviation community flourished. Enthusiasts subscribed to the leading journals of the day, which included drawings of successful designs. Aircraft similar to modern ultralights were inexpensive to build. The stumbling block usually proved to be inadequate engines. Immediately before the United States entered World War I in 1917, interest waned, perhaps because of the intense litigation battles between the Wright brothers and Curtiss over patent rights.

World War I changed the playing field entirely. Wartime needs prompted the development of much more robust aircraft. Small manufacturers struggled; those with deep pockets, like William Boeing, survived. Much to the chagrin of Boeing and other aviation industrialists, the federal government after the war chose to sell military surplus aircraft and engines to the general public at dirt-cheap prices. Until the emergence of the commercial airmail routes in the late 1920s, all serious manufacturers depended on military contracts.

Individuals trying to operate commercially in the Seattle area faced a significant limitation—inadequate landing fields. The most successful operator, Eddie Hubbard, flew either floatplanes or flying boats on the Seattle–Victoria, British Columbia, airmail run.

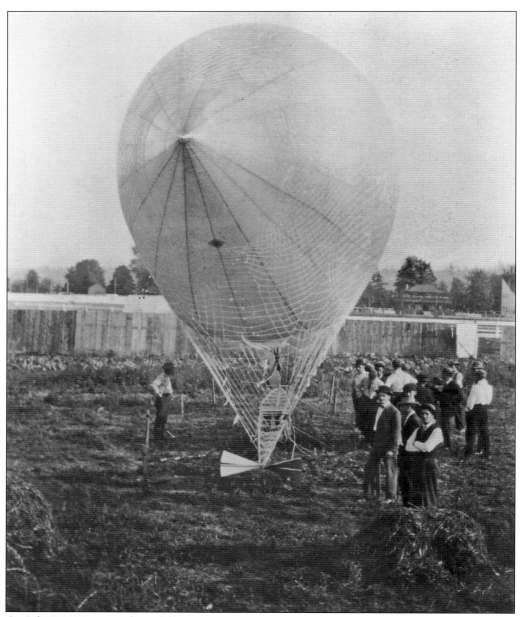

On July 4, 1908, a crowd carefully examines Guy Mecklem's dirigible at the Meadows, a racetrack and amusement center a few miles south of downtown Seattle. On the second of three flights that summer, Mecklem, a veteran hot-air balloonist who worked up and down the West Coast, beat two automobiles in a race from Luna Park at West Seattle's Alki Point to the Meadows. He considered that flight his most dangerous because of residents shooting off fireworks. Mecklem then took his dirigible on the road, performing in the southwest and California in 1909. At the air show in Los Angeles the next year, he claims to have soloed in noted French flyer Louis Palham's Farman biplane after the veteran pilot became ill. Mecklem later returned to Seattle and owned a half interest in a Tom Hamilton–built biplane that he repeatedly crashed because it was underpowered. (BA.)

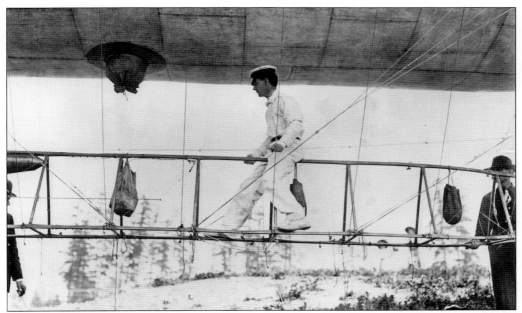

J. C. "Bud" Mars (center) demonstrates how to control his dirigible by walking beneath the craft on the Alaska-Yukon-Pacific Exposition grounds in Seattle. Mars made his first parachute jump from a hot-air balloon at age 16. He learned about dirigibles working for Thomas Baldwin, among the first to fly dirigibles in the United States. (University of Washington Libraries, Special Collections UW18368.)

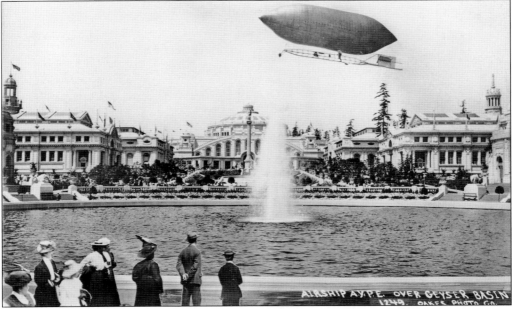

The dirigible operated by J. C. "Bud" Mars flies above the Alaska-Yukon-Pacific Exposition on the University of Washington campus in the summer of 1909. For the first time, many Seattle residents were able to view a controlled and powered craft in flight. Mars brought his dirigible from California for the event. (University of Washington Libraries, Special Collections UW23078.)

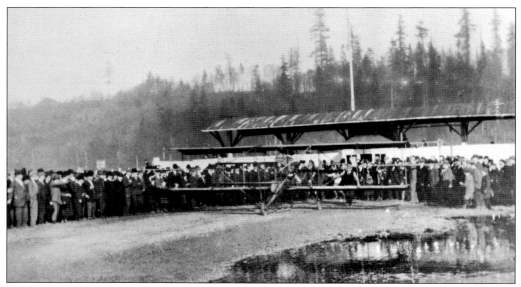

In March 1910, enthusiastic spectators crowd close to Charles Hamilton's Curtiss pusher during his visit to the Meadows. The railroads provided special train service to the site south of Seattle. Undoubtedly, some onlookers used the opportunity to formulate plans for building their own airplane as this design was widely copied. (MOHAI.)

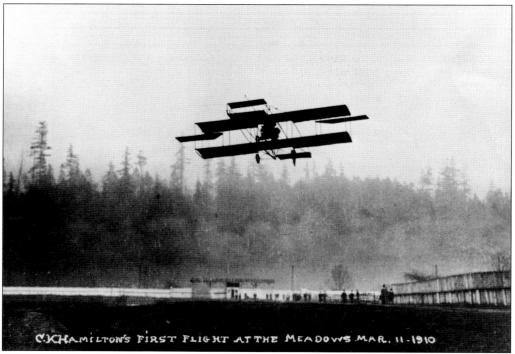

C.K.HAMILTON'S FIRST FLIGHT AT THE MEADOWS MAR. 11-1910

Before crashing into the pond in the interior of the racetrack, Hamilton thrilled crowds as he soared above the Meadows near Seattle. Representing Glenn Curtiss, Hamilton flew the same aircraft that the legendary aviator had raced past the Europeans at Reims, France, in 1909. Like other early flyers, Hamilton first took to the skies in hot-air balloons. (TMOF.)

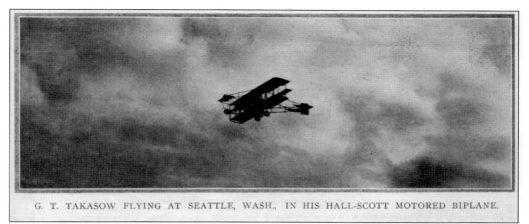

G. T. TAKASOW FLYING AT SEATTLE, WASH., IN HIS HALL-SCOTT MOTORED BIPLANE.

In 1913, George Takasou flew above Seattle in this photograph printed in *Aero and Hydro*. Takasou was probably the first person to build and fly an airplane in Seattle. He flew his first plane briefly near Kent, south of Seattle, in April 1911. Takasou continued to improve his designs and flying skills so that by 1913 he was an accomplished pilot. Returning to his native Japan, he strongly influenced early Japanese naval aviation. (TMOF.)

After incorporating his airplane company in September 1910, Eugene Romano built a hangar on the south end of Seattle's Harbor Island from where pilot Roger Varicle, a native of France, conducted test flights in the so-called "Flying Bed Post" in 1911 and 1912. Romano failed to acquire an engine of sufficient power despite advertising in the trade publications of the time. By 1913, he turned his attention to automobiles. (MOHAI-P.)

13

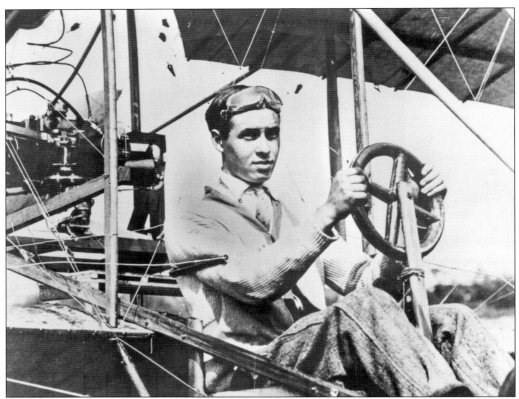

As a 17 year old in 1911, Seattle-based Tom Hamilton was building and selling airplanes to overseas customers. Hamilton probably flew for the first time about a month after George Takasou in May 1911. Takasou became one of his customers. Good at marketing, Hamilton relaxes in one of his early designs. (MOHAI.)

This advertisement from *Aero and Hydro* demonstrates Hamilton's marketing sophistication. His 50-page catalog may be viewed at the Seattle Public Library. Hamilton moved briefly to Vancouver, British Columbia, and then to Milwaukee, Wisconsin, where his company landed a huge contract for propellers. Hamilton sold out to the United Aircraft and Transport Corporation, headed by William Boeing, in the late 1920s. (TMOF.)

In June 1911, California-based Charles Walsh visited Seattle on a tour of the Pacific Northwest. Able to easily pack their lightweight aircraft into crates, exhibition flyers like Walsh traveled from town to town by train. About 2,000 spectators paid to see Walsh, who was accompanied by mechanic Harry Christofferson of Portland. (MOHAI-P.)

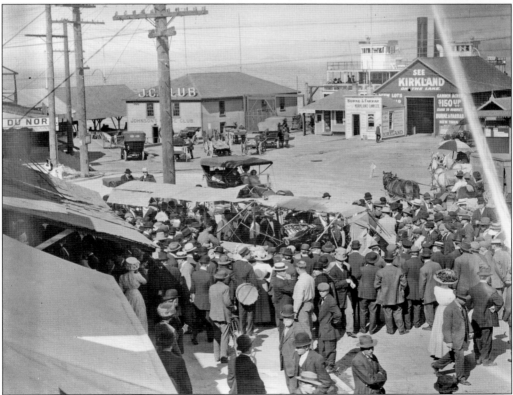

Crowds gather around the wreckage of Charles Walsh's pusher near Seattle's Madison Park ferry terminal. Unexpected winds easily affected these fragile aircraft. Before he could recover, Walsh was forced into a pole as his wife and children watched. The aircraft crashed to the pavement, and he escaped with relatively minor injuries, only to perish in October 1912. (MOHAI-P.)

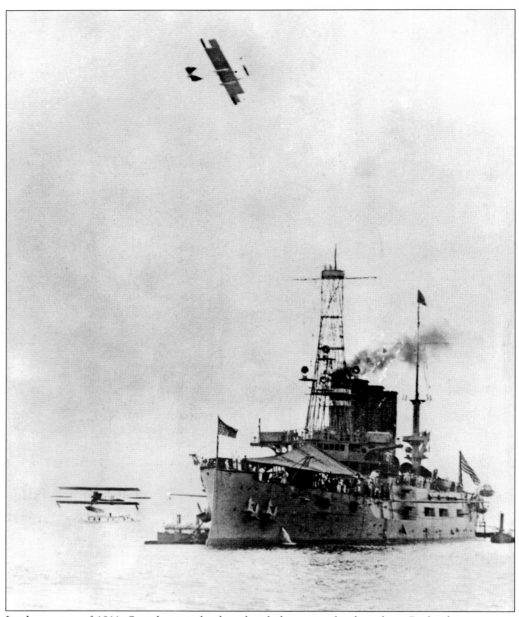

In the spring of 1911, Seattle civic leaders decided to raise funds to host Potlatch, a summer celebration. In the early years, the festival featured flying exhibitions, including the appearance in July 1911 by Hugh Robinson (lower left) and Eugene Ely (above), members of the Curtiss team. Robinson flew a hydro-aeroplane (note the single float), an innovation introduced by Glenn Curtiss earlier in the year while headquartered in San Diego, California, for the winter. Ely was the first person to land on and take off from a naval vessel. They used Harbor Island southwest of downtown as their operations base. (MOHAI.)

In March 1912, James Martin informed the Seattle Press Club of his plans to form an aero club and make the community a regional hub for aviation. Martin convinced civic leaders to pay him a large cash advance for a flying exhibition at the 1912 Potlatch. Once Potlatch began, Walter Edwards dominated the flying as Martin time and again found an excuse not to fly. His obvious reluctance, something for which he had earned a reputation in Boston in 1911, led to considerable criticism from a *Seattle Times* reporter. He finally flew on the final day. Martin sued the paper for libel but lost in a case decided late in 1913. (National Air and Space Museum, Smithsonian Institution, SI 77-1854.)

Activity at the Flying Fields

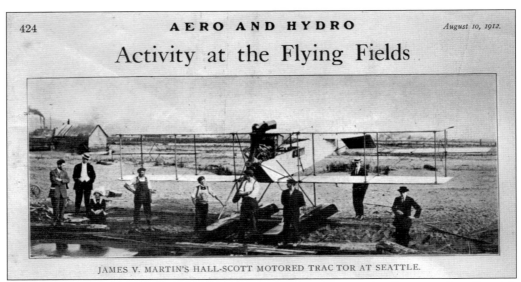

JAMES V. MARTIN'S HALL-SCOTT MOTORED TRACTOR AT SEATTLE.

James Martin mastered the art of public relations with this photograph of his aircraft on Seattle's Harbor Island in an August 1912 issue of *Aero and Hydro*. While this photograph shows the aircraft on floats, newspaper accounts suggested that he used wheels at Potlatch that summer. Martin took the same plane to Fairbanks the following summer and became the first person to fly in Alaska. (TMOF.)

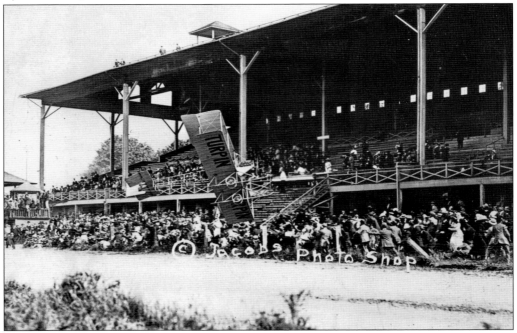

In May 1912, exhibition flyer Cliff Turpin veered into the stands at the Meadows. Turpin lost control trying to avoid an amateur photographer who ran into his path during a low pass. One spectator died at the scene, a second succumbed in a Seattle hospital a few days later. As Turpin recovered from his injuries, partner Phil Parmalee traveled to Yakima, where he crashed, dying almost instantly. (TMOF.)

In 1913, the Hall-Scott Motor Company pinpoints an emerging market, aircraft engines, with this advertisement in *Aero and Hydro* celebrating Alys McKey's record-setting flight above Seattle during the 1913 Potlatch. McKey became the first woman to fly in Washington state while on a Northwest tour that spring and summer. In newspaper interviews, she commented on the tricky wind conditions around the looming Smith Tower. Responding to an advertisement, McKey had learned to fly with the California-based Bryant brothers. She married Johnny Bryant that summer only to see him die in a crash in Victoria, British Columbia, a few months later. (TMOF.)

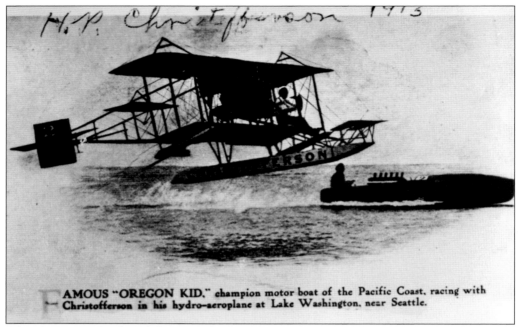

AMOUS "OREGON KID." champion motor-boat of the Pacific Coast, racing with Christofferson in his hydro-aeroplane at Lake Washington, near Seattle.

After the 1913 Potlatch ended, Harry Christofferson raced the hottest speed boat in the Northwest. Christofferson easily beat the *Oregon Kid* during the match race on Lake Washington just east of Seattle's Madison Park. Christofferson and his younger brother, Silas, came up from their California headquarters for the Potlatch in 1913, 1914, and 1915. (TMOF.)

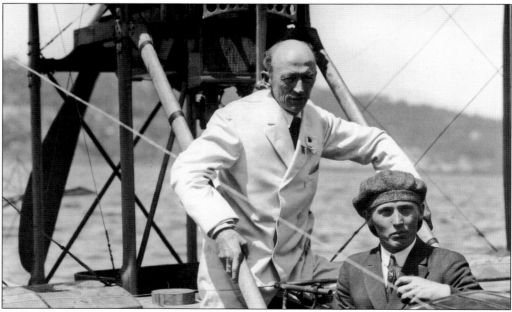

During his Potlatch visit in 1915, Silas Christofferson prepares to give Seattle mayor Hiram Gill a ride in his flying boat. Before his death in 1916, Christofferson had established himself as one of the leading aviation innovators on the West Coast. His company built aircraft and engines, operated a flying school, and conducted charters. (MOHAI-P.)

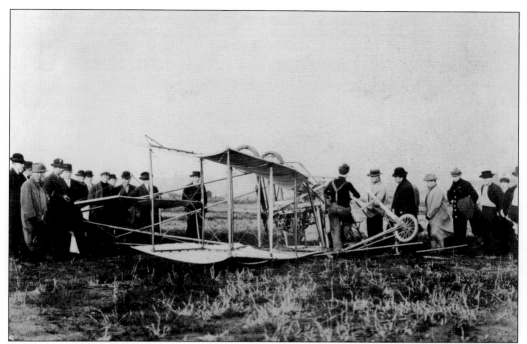

In December 1912 on Seattle's Harbor Island, a crowd examined the wreck of an aircraft flown by Walter Edwards. Edwards was the first to carry mail in Washington State, flying from Portland, Oregon, to Vancouver, Washington, in August 1912. He returned to the Seattle area for several months and, with help from local enthusiast Herb Munter, built this aircraft. (BA.)

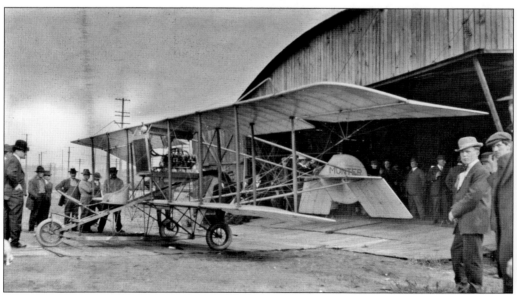

In the summer of 1915, a crowd gathered around Herb Munter's aircraft next to the old Romano hangar on Seattle's Harbor Island. Munter flew with Puyallup's Harvey Crawford over Tacoma in 1913 and probably soloed first in July 1914. By 1916, he was touring the western states on a regular basis. William Boeing hired Munter as his company's first pilot. (TMOF.)

In 1920, Munter Field next to downtown Kent featured a small hangar, home of Herb Munter's Aerial Tours. Always the entrepreneur, Munter operated the company for a short time until a fire wiped him out. Though he flew occasionally, he focused on the automobile business before returning to commercial aviation in the 1930s. (TMOF.)

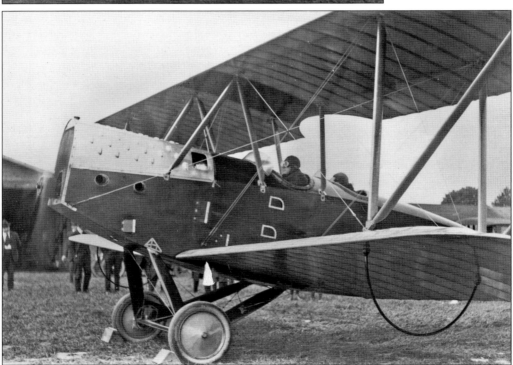

The wheel chocks need to be removed before Herb Munter (rear seat) can take a passenger for a ride in his Boeing BB-L6 from Munter Field in Kent in 1920. Munter achieved several milestones in this aircraft, including the first to fly over Mount Rainier and the first to fly around the state with passengers. (TMOF.)

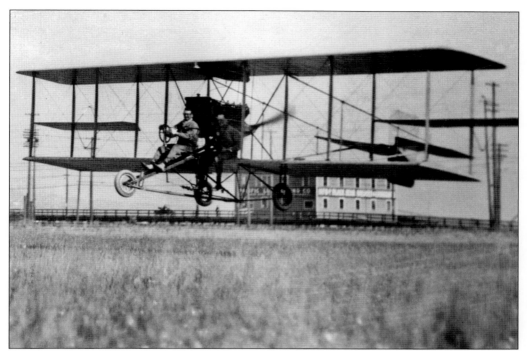

Terah Maroney pilots his pusher over Seattle's Harbor Island in 1915 or 1916. Maroney first arrived in Everett in 1914. At the conclusion of the 1914 Potlatch, he flew to Lake Union, where he hoped to race Silas Christofferson. Christofferson declined. It is quite possible that during this visit to Seattle Maroney gave William Boeing his first plane ride. (TMOF.)

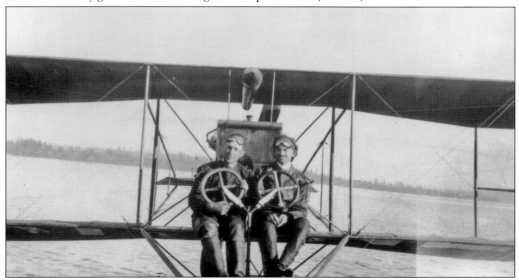

In 1915, Terah Maroney (right) prepares to give Eddie Hubbard a flying lesson. Maroney set up shop on Lake Washington by operating a flying school near Seattle's Leschi Park. Maroney could change his pusher, shown here on a float, into a land plane if he chose. During World War I, Hubbard served as an Army Air Service instructor in San Diego before returning to Seattle to fly for Boeing. (Montana State Historical Society.)

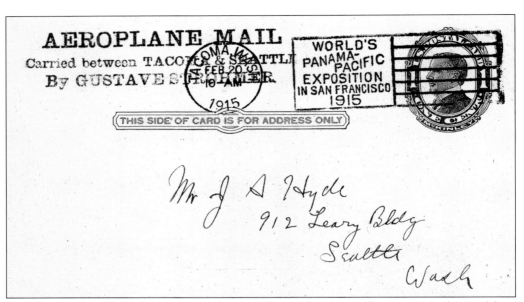

AEROPLANE MAIL
Carried between TACOMA & SEATTLE
By GUSTAVE STROHMER.

WORLD'S
PANAMA-
PACIFIC
EXPOSITION
IN SAN FRANCISCO
1915

THIS SIDE OF CARD IS FOR ADDRESS ONLY

Mr J A Hyde
912 Leary Bldg
Seattle
Wash

On February 20, 1915, Gustave Strohmer flew a small quantity of post office–sanctioned airmail from Tacoma to Seattle in his homebuilt hydro-aeroplane. He carried one passenger and approximately 45 pieces of mail, including a few registered letters. This postcard was part of the mail shipment. It had the simple message on the back, "First Aeroplane to carry mail from Tacoma to Seattle. 2/20/15." (EDC.)

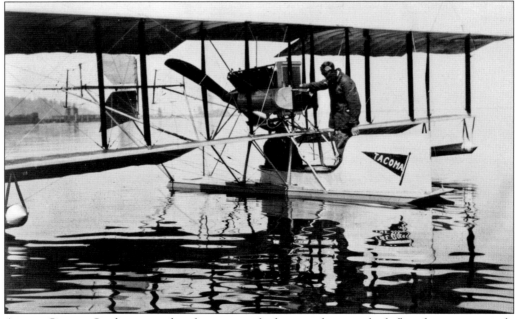

Aviator Gustave Strohmer stands in his two-seat hydro-aeroplane in which flew the approximately 24 miles from Tacoma to Harbor Island in Seattle in just under 30 minutes. His passenger was Jane O'Roark, an actress appearing at the Empress Theater in Tacoma. Seeking publicity, the flight was billed as a contest between the plane and Jack Haswell in his Maxwell automobile, a race that Strohmer won by a significant margin. (BA.)

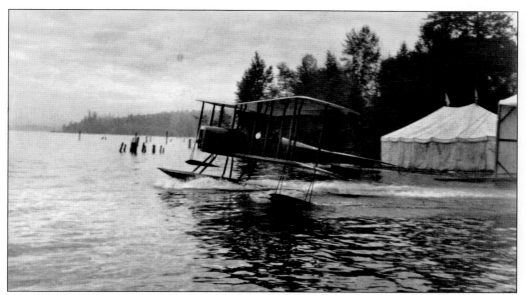

Possibly with Floyd Smith at the controls, William Boeing's Martin TA departs from the Lake Washington shore in late 1915. Boeing had traveled to Los Angeles, where he took flying lessons from Smith, who worked for Glenn Martin. Percy Barnes later operated the TA on wheels around Tacoma. (BA.)

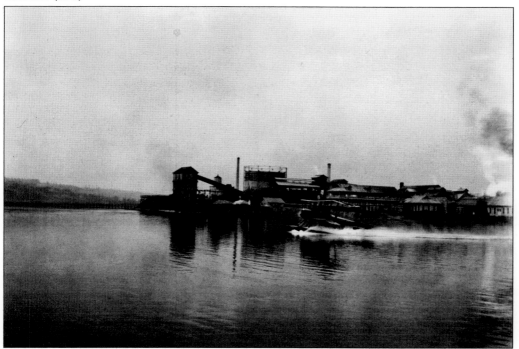

Known as the B&W for William Boeing and Conrad Westervelt, the first Boeing airplane gains speed before taking off from Seattle's Lake Union opposite the gas works. Unable to interest the federal government in two B&W trainers in 1916, Boeing sold them to New Zealand interests. (TMOF.)

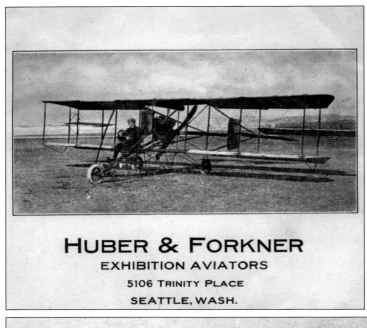

HUBER & FORKNER
EXHIBITION AVIATORS
5106 TRINITY PLACE
SEATTLE, WASH.

The exhibition duo of Leo Huber and Joe Forker hoped this flyer would interest potential customers in the commercial benefits of their air service in 1916. By 1917, Huber and Forker operated several Curtiss flying boats as Washington Airplane Service at the east end of Madison Street on Seattle's Lake Washington. (TMOF.)

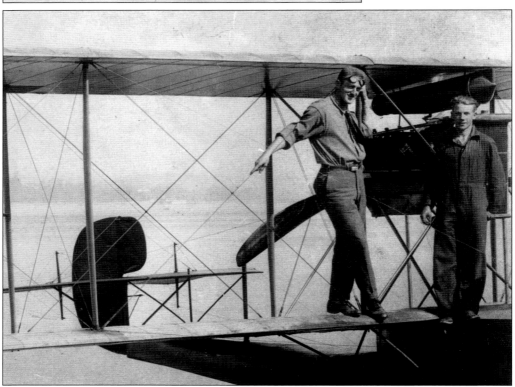

Instructor pilot Joe Forker (left) and mechanic Frank Wadman pause on a wing of a Washington Airplane Service flying boat on Lake Washington in 1917. Forker spent most of his military career in the Naval Reserve at Sand Point. Wadman soloed in May 1917 in one of the company's Curtiss flying boats. He worked extensively with pioneer aviators in southeast Alaska. (TMOF.)

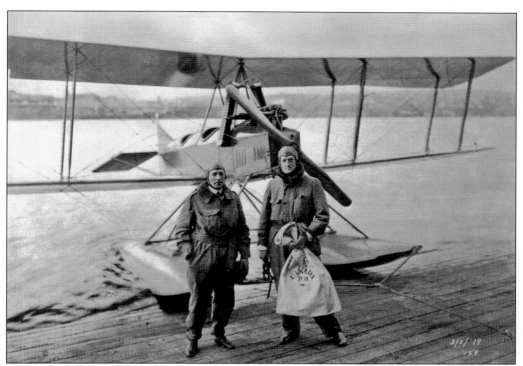

Eddie Hubbard (left) and William Boeing have arrived at the Boeing hangar on the east shore of Lake Union. The special airmail flight in Boeing's personal Boeing Model CL-4S from Vancouver, British Columbia, to Seattle demonstrated the commercial viability of the airplane. The bag is on display in the Museum of Flight's Red Barn. (EDC)

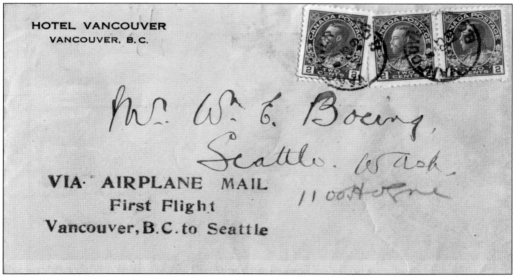

This envelope is from one of 60 in the mailbag that Eddie Hubbard and William Boeing flew from Vancouver, British Columbia, to Seattle's Lake Union in March 1919. Just one month earlier, Pres. Woodrow Wilson had lifted the ban on nonmilitary flying that had been in place since March 1918 because of World War I. (TMOF.)

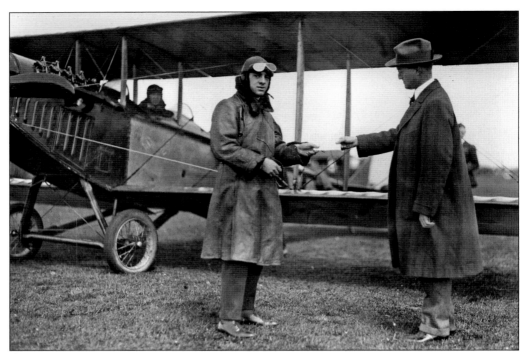

On Monday, May 19, 1919, at Jefferson Park Golf Course on Seattle's Beacon Hill, William Boeing handed to Lt. Robert Rideout what is perhaps the first piece of airmail correspondence between Seattle and Victoria, British Columbia. The aircraft is a Curtiss JN-4 Jenny of the Aerial League of Canada flown by pilots Rideout and Lt. Harry Brown to promote the upcoming 24th of May celebrations in Victoria. (MOHAI-P.)

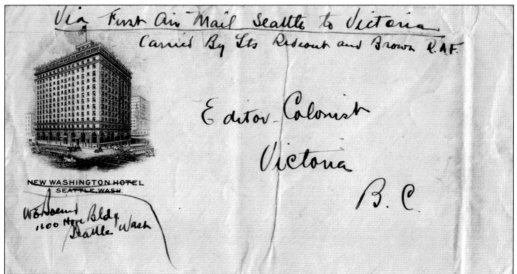

The envelope carried aboard the Canadian Jenny and addressed to the editor of the *Colonist* newspaper in Victoria and the enclosed note written by Boeing as a souvenir of what he described as "the first International Mail between Seattle and Victoria" were donated to the Museum of Flight in Seattle by Bill Boeing Jr. in 2008. (TMOF.)

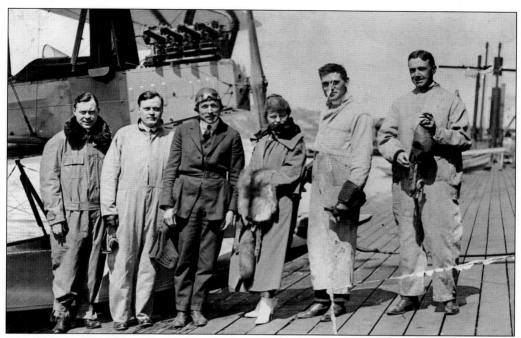

Pilot Eddie Hubbard (third from left) joins prospective passengers before taking them on individual sightseeing flights over Seattle in May 1919. The Boeing Airplane Company briefly operated the Sky Taxi from the company's seaplane hangar on the east side of Seattle's Lake Union. Hubbard used the CL-4S, a modified version of the Boeing Model C that had flown to Vancouver, British Columbia, and back in March. (BA.)

In October 1920, Eddie Hubbard, backed by Boeing's Philip Johnson, initiated the Seattle–Victoria, British Columbia, airmail contract. Originally, Hubbard operated a Boeing Model C on the route—intended to deliver mail to steamships bound for the Far East. On the return, he carried mail from inbound liners to Seattle for points east and south. (MOHAI-P.)

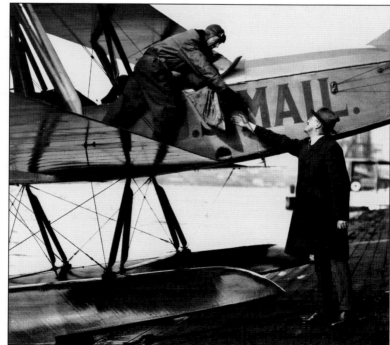

After World War I, Boeing attempted to interest the public in its Model C with this advertisement in *Aerial Age Weekly*. Boeing built 50 Model C trainers for the U.S. Navy. The glut of surplus military aircraft prevented the company from attracting customers for new Model Cs and steered it away from commercial aviation. (TMOF.)

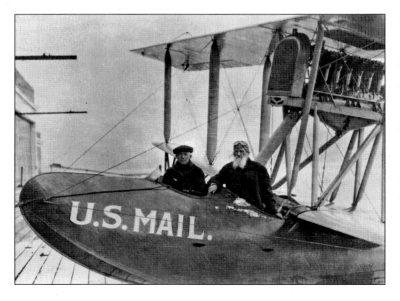

Legendary Puget Sound pioneer Ezra Meeker (right) and pilot Eddie Hubbard go for a ride in Hubbard's Boeing B-1 mail plane, his primary aircraft for the Seattle–Victoria, British Columbia, airmail route. Meeker, who crossed the country in the 1850s in an oxen-pulled wagon, also coaxed airplane rides out of Spokane's Nick Mamer and Tacoma's Percy Barnes. (TMOF.)

Eddie Hubbard's famous B-1 mail plane appears to be rotting away at Seattle's Boeing Field in the late 1930s. Hubbard used the aircraft for several years before leaving the business. The plane eventually passed into the hands of Northwest Air Service, which briefly held the U.S. Post Office Department's Seattle–Victoria Foreign Air Mail 2 contract in the late 1920s. (TMOF.)

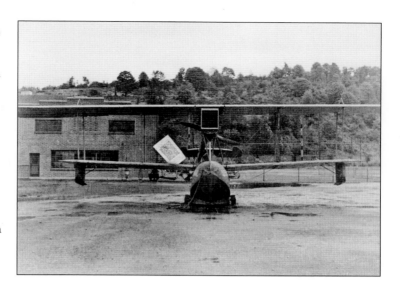

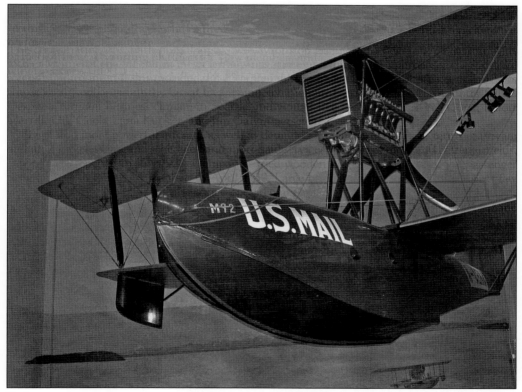

Each year, thousands of visitors to Seattle's Museum of History and Industry see the Boeing B-1 on display. This is the oldest surviving Boeing airplane. Originally a 200-horsepower Hall-Scott L-6 engine powered the B-1, but this was later replaced with a 400-horsepower Liberty. From 1920 to 1928, this aircraft was used to fly the mail between Seattle and Victoria, British Columbia. (ED)

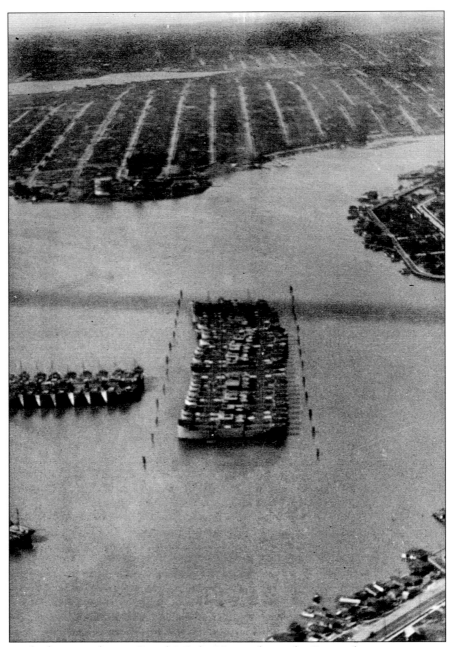

This view looking north over Seattle's Lake Union shows the Boeing hangar jutting out from the right, or east, shoreline opposite the gas works. William Boeing originally intended for his hangar design to be widely copied and used as a model for seaplane stations. Prior to the United States' entry into World War I, defense officials were concerned that German naval vessels, particularly submarines, posed a threat to West Coast shipping. To counter them, the government considered establishing seaplane bases 50 miles apart, from which aircraft could conduct surveillance flights. The idea, however, was dropped before the United States entered the war in April 1917. (TMOF.)

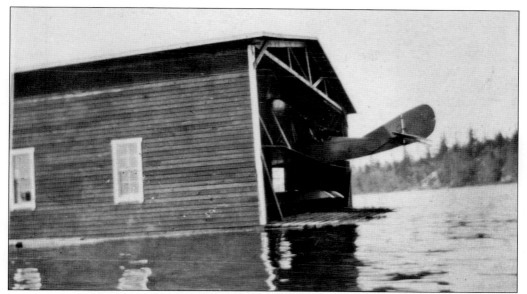

Charles Hammontree's Boeing Model C sticks out the back of his floating hangar. In 1919, Hammontree briefly operated an air service linking Bremerton and Seattle. He used the hangar in Bremerton and then moved it to Lake Union. In 1922, Hammontree shipped his Model C to Anchorage, Alaska, and became the first person to fly an airplane there. (TMOF.)

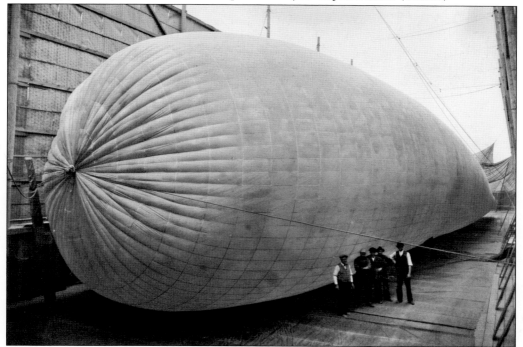

A dirigible takes shape at the Harvey-Campbell Aircraft Company near the corner of Michigan Street and First Avenue in south Seattle in 1919. The potential of dirigibles as passenger liners after their military use in World War I fascinated entrepreneurs. Dirigibles were much more popular in Germany and Great Britain. (MOHAI-P.)

33

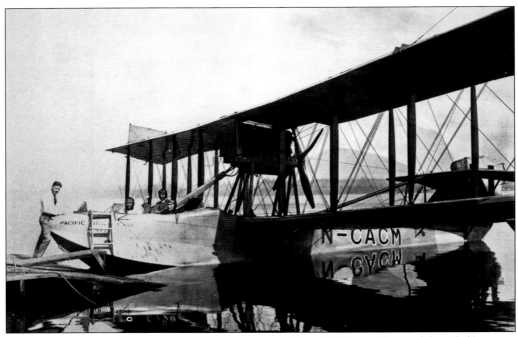

Anscel Eckman (second from left) waits in the cockpit of *Blue Bird*, his Curtiss HS-2L flying boat he operated as Pacific International Airways in the early 1920s. The big navy flying boats with their 450-horsepower Liberty engines had previously appeared in Seattle. Boeing built up to 25 under a navy contract in 1918. Eckman briefly held the Seattle–Victoria, British Columbia, airmail contract. (TMOF.)

To arouse interest in his charter service, Anscel Eckman distributed business cards like this one around Seattle in the mid-1920s. Interestingly, several spots on Seattle's Lake Washington shore served as bases of operation. Eckman chose Madrona, whereas other flyers had set up shop at Madison Park and Leschi. Meanwhile, Sand Point, farther north, catered primarily to military aviators. (TMOF.)

Two

AIRMAIL AND AIRLINES SERVING SEATTLE

The U.S. Post Office demonstrated the practical operation of a scheduled transcontinental airmail service when on September 8, 1920, it began a service from New York to San Francisco. The aircraft were converted open cockpit military De Havilland D.H. 4 biplanes flying from grass fields over a crudely lit airway and changing pilots and planes at Pony Express–type way stations set up along the 2,665-mile route.

The Kelly Act, signed into law on February 2, 1925, legislated that the post office hand over the operation to private companies. A process of competitive bidding, overseen by the post office department, awarded the transcontinental route and a series of new feeder lines to the successful bidder. The first of the new routes was awarded in October 1925. The longest of them, Contract Air Mail Route 8 (CAM 8), stretched 1,099 miles from Seattle to Los Angeles. It was awarded to Oregon coach line operator Vern Gorst. He formed a new operating company, Pacific Air Transport, surveyed the route, negotiated for landing fields, erected a series of beacon navigation lights, hired pilots and ground staff, and acquired a mixed fleet of small planes. Though not initially encouraged, the aircraft were capable, and the contract allowed for the carrying of fare-paying passengers. Daily service, except Monday, was inaugurated on September 15, 1926.

Walter Varney was the successful bidder for CAM 5 and inaugurated service between Pasco, Washington, and Elko, Nevada, on April 6, 1926, extending service to Seattle in September 1929.

William Boeing was the winner of the western half of the transcontinental bid, and his Boeing Air Transport (BAT) began operation of the San Francisco–to–Chicago CAM 18 on July 1, 1927. The Boeing Airplane Company designed and built a new airmail plane for BAT that had an enclosed two-place passenger cabin, generating incremental revenue over and above the mail payments.

The start of the CAM routes marked the birth of the airline industry in the United States, with PAT, Varney, and BAT, through mergers and acquisitions, eventually becoming the founding companies of today's United Airlines.

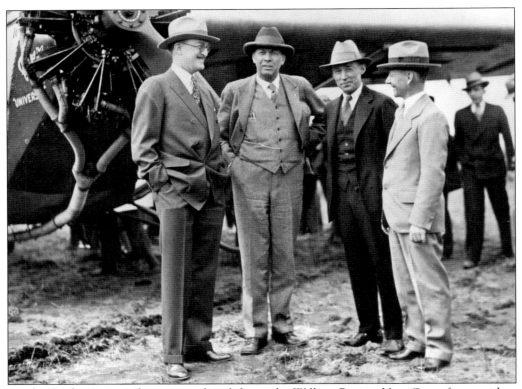

Pacific Northwest airmail pioneers—from left to right, William Boeing; Vern Gorst, first president and founder of Pacific Air Transport; Eddie Hubbard, who flew Foreign Air Mail Contract 2 between Seattle and Victoria, British Columbia; and Frank Bell, representing Varney Air Lines, whose planes flew CAM 5 service between Pasco, Washington, and Elko, Nevada—gather in front of a Fokker Universal. (TMOF.)

Mail is unloaded from the forward mail pit, behind which is the passenger cabin, then a second mail pit, and the pilot's open cockpit of this Seattle-built Boeing Model 40A mail plane. The plane was a strategically important design that gave the fledgling airlines the power and payload they needed, plus the added advantage of an enclosed passenger cabin. (BA.)

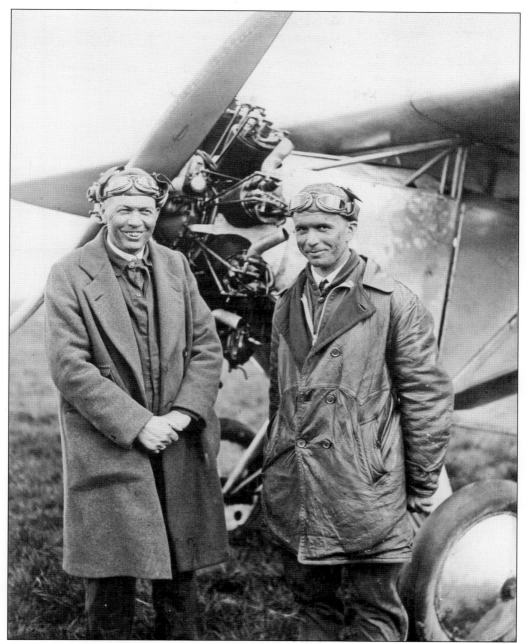

Vernon Centennial Gorst (left), founder and first president of Pacific Air Transport Inc., and Tubal Claude Ryan, pictured at Seattle's Sand Point airfield on March 18, 1926, had just completed a survey flight from Los Angeles to Seattle over CAM Route 8. The U.S. Post Office Department had recently awarded the route to Gorst. The plane behind them is the one that they used to check out the 1,150-mile airway, an M-1 built by Ryan's San Diego aircraft manufacturing company. A full-size replica of this "Survey Plane" can be seen at the San Diego Air and Space Museum. (EDC.)

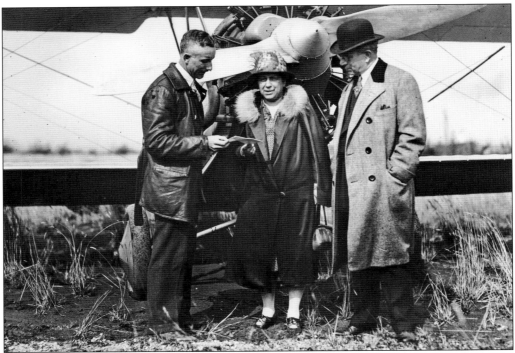

Pacific Air Transport inaugurated airmail service for CAM 8 on September 15, 1926. The photograph shows pilot Grover Tyler (left), with his Travel Air biplane in the background, handing over a piece of ceremonial mail to Seattle mayor Bertha Landes. On the right is J. W. Spangler, president of the Seattle Chamber of Commerce. (MOHAI-P.)

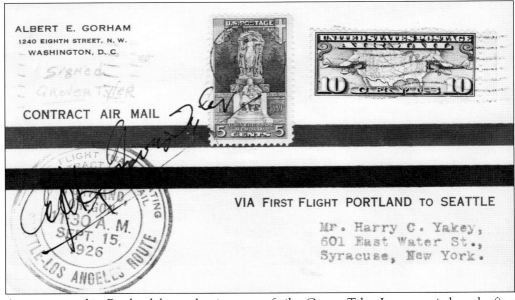

A cover, posted in Portland, bears the signature of pilot Grover Tyler. It was carried on the first flight of Pacific Air Transport over CAM 8 to Seattle, and then back stamped in Seattle. With sufficient postage, it continued by airmail to New York. (EDC.)

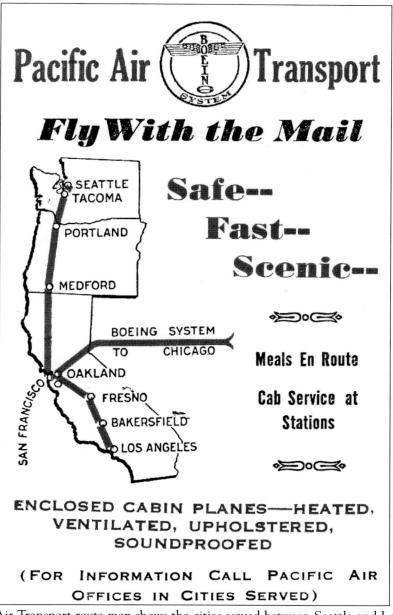

A Pacific Air Transport route map shows the cities served between Seattle and Los Angeles and the connection to the Boeing Air Transport line at Oakland. On July 1, 1930, the line was extended south to San Diego. Vern Gorst, who had first flown a Martin biplane in 1913 while operating bus lines based in Coos Bay, Oregon, made his fortune in the Alaska gold rush of the late 1890s. With an affinity for aviation and recognizing a business opportunity, Gorst was able to secure financial backing primarily from Portland's business elite and acquire the West Coast airmail contract in the name of Pacific Air Transport. Running an airline proved to be far more expensive than he anticipated. He sold out to Boeing on the advice of a young San Francisco banker, William Patterson. Patterson eventually moved to Boeing and later became the president and chairman of United Air Lines. (EDC.)

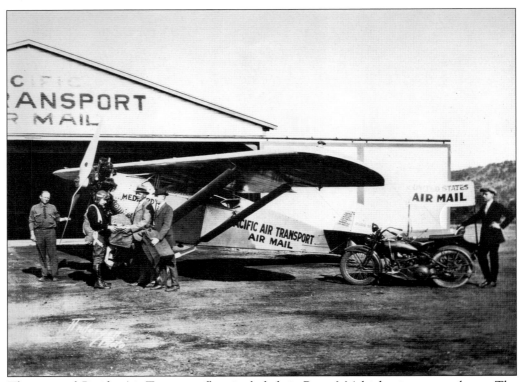

The original Pacific Air Transport fleet included six Ryan M-1 high-wing monoplanes. The photograph shows the No. 1 M-1 with pilot R. B. Patterson accepting the mail to be flown south from Medford, Oregon, on the first day of service. (TMOF.)

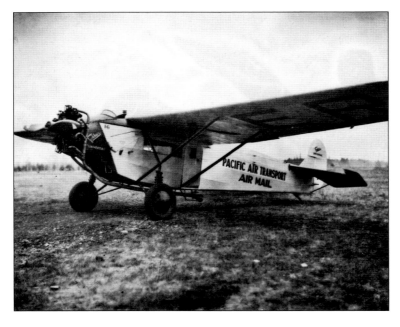

In April 1927, Pacific Air Transport took delivery of a new Fokker Universal, which was placed in service between Seattle and San Francisco. The enclosed cabin, with up to six seats, considerably enhanced the comfort of the airline's expanding passenger business. However, the pilot continued to brave the elements in the open cockpit.(TMOF.)

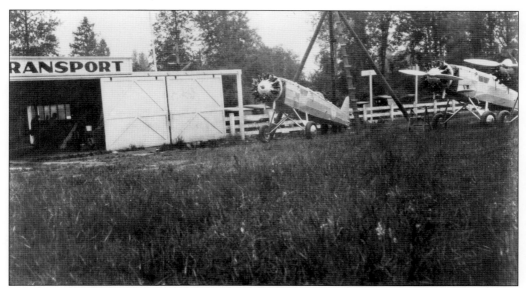

This June 1927 photograph shows Seattle's Sand Point airfield with Pacific Air Transport's primitive hanger. The aircraft are the initial batch of 25 Boeing Model 40A mail planes that were barged to Sand Point for final assembly and flight-testing, then flown to BAT stations between San Francisco and Chicago in time for the July 1, 1927, inauguration of service over the CAM 18 route. (BA.)

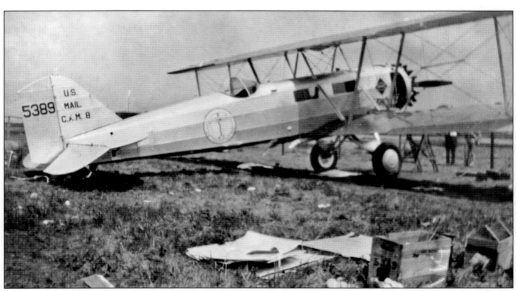

Following Boeing Air Transport's January 1928 takeover of Pacific Air Transport, the new PAT board authorized the purchase of four Boeing 40C mail and passenger planes for the coastal airline. The first 40Cs were barged to Gorst Field, where this picture was taken, for final assembly and flight-test. No. 5389, later named *Shasta*, was delivered to PAT on May 17, 1928. (BA.)

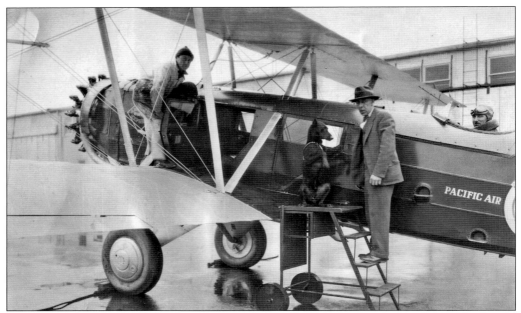

Seattle's famous police dog, a Doberman named Arnold von Winkelried, is ready to board a PAT Boeing 40B-4 that would take him to San Francisco to assist in a kidnapping case. For this special case, the airline waved its policy of not transporting dogs but charged $80 for Winkelried's seat. The pilot is Grover Tyler, and the gentleman on the steps is probably the dog's handler, A. T. Sanderlin. (BA.)

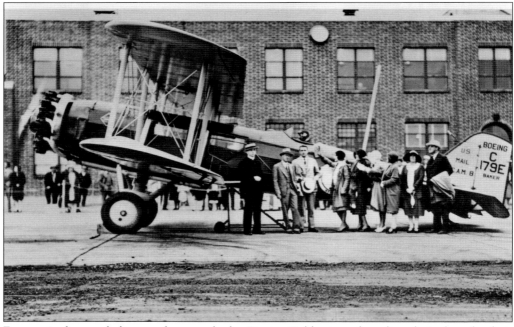

Four excited young ladies are photographed at Boeing Field prior to boarding their plane for their flight to San Diego probably late in 1930. The plane is one of Pacific Air Transport's four-passenger Boeing 40B-4s, all of which were named after West Coast mountains, in this case *Baker*. (BA.)

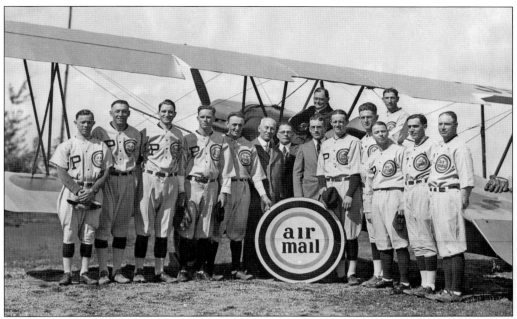

The nation's first airmail baseball team played the 1928 season in the Industrial League of Seattle. In the cockpit of the Stearman is Seattle postmaster C. M. Perkins. Directly in front of him is C. V. O'Callaghan, traffic manager for Varney Air Lines. The distinguished gentleman on the left of the three in civilian clothes is W. Irving Glover, second assistant postmaster general. (TMOF.)

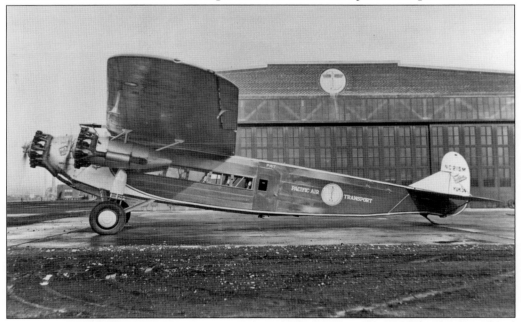

On March 17, 1931, Pacific Air Transport announced it had acquired the routes and assets of rival West Coast Air Transport, a division of Western Air Express. Among the assets were three Fokker F-10 Super Trimotor 12-passenger monoplanes, including the *Yukon*, pictured here at Boeing Field. The Fokkers were repainted in PAT's silver and green livery. (TMOF.)

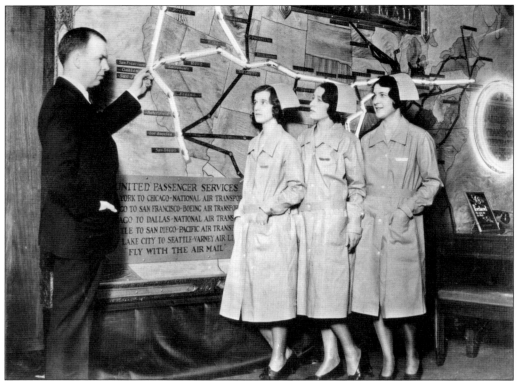

Steve Stimpson, who introduced the stewardess program within the United group of airlines, shows Pacific Air Transport's first three stewardesses the route that they will be flying. Hired in Seattle for the new daylight passenger service to San Francisco that commenced April 1, 1931, the young ladies are, from left to right, Clara Johnson, Maye Eastman, and Mildred Schilling. (TMOF.)

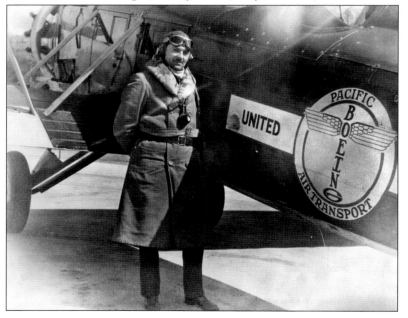

Veteran Pacific Air Transport pilot Frank Anderline models his flying gear in front of his Boeing 40B-4 mail and passenger plane. Anderline was killed in July 1939 in England, where he was test flying a Lockheed Hudson prior to its delivery to the Royal Air Force. (TMOF.)

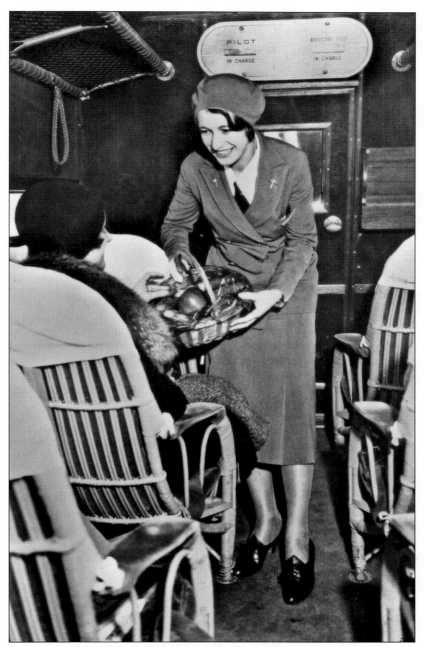

With the acquisition of the WCAT Fokker F-10s, Pacific Air Transport inaugurated a new daylight passenger service between Seattle and San Francisco on April 1, 1931. The airline also hired three registered nurses for their first stewardess service. Maye Eastman, one of these young ladies, serves a snack to one of her passengers aboard the F-10. PAT only operated the former WCAT Fokkers for a brief time. After legendary University of Notre Dame football coach Knute Rockne was killed in an F-10 crash in the Midwest, federal officials raised concerns about the aircraft's dependability. PAT quickly replaced them with Ford Tri-Motors. (TMOF.)

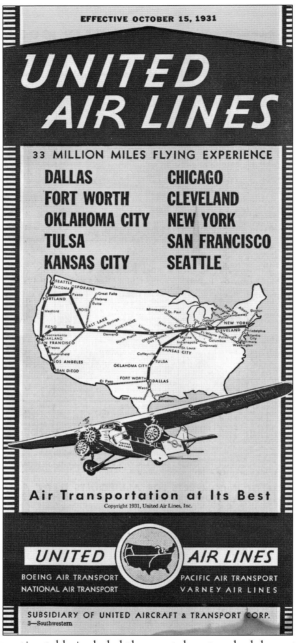

EFFECTIVE OCTOBER 15, 1931

UNITED AIR LINES

33 MILLION MILES FLYING EXPERIENCE

DALLAS	CHICAGO
FORT WORTH	CLEVELAND
OKLAHOMA CITY	NEW YORK
TULSA	SAN FRANCISCO
KANSAS CITY	SEATTLE

Air Transportation at Its Best

Copyright 1931, United Air Lines, Inc.

UNITED AIR LINES

BOEING AIR TRANSPORT PACIFIC AIR TRANSPORT
NATIONAL AIR TRANSPORT VARNEY AIR LINES

SUBSIDIARY OF UNITED AIRCRAFT & TRANSPORT CORP.
3—Southwestern

This United Air Lines timetable included the coastal route schedules out of Seattle, offering two daily round-trips to San Diego. Ford Tri-Motors handled the daylight passenger service with a scheduled flight time of 11 hours, 40 minutes. Boeing 40B-4s, which could also carry four passengers, flew the night mail. At this time, United and Boeing were part of the United Aircraft and Transport Corporation. In 1934, the federal government ordered the breakup of this and several other aviation conglomerates. As a separate entity, United Air Lines established its corporate headquarters in Chicago. Ironically, Boeing would move its headquarters to Chicago about 70 years later. (TMOF.)

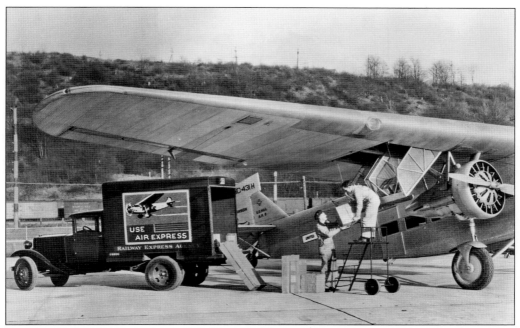

On May 28, 1931, PAT inaugurated the Daylight Flyer passenger service between Seattle and San Diego with its new fleet of Ford Tri-Motors. PAT slashed fares between the two cities to $84 each way. This Boeing Field photograph shows Railway Express freight being unloaded from a Ford's wing baggage compartment. (BA.)

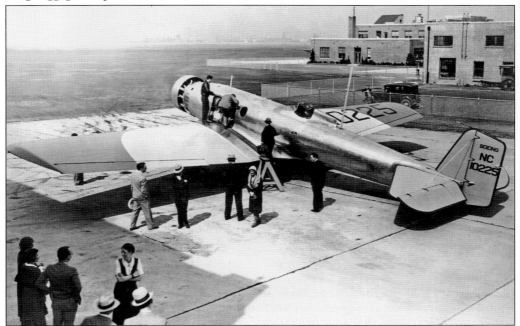

The Boeing Model 221A Monomail, an experimental mail and eight-passenger plane, made its first flight on August 18, 1930. At Boeing Field, passengers use a precarious wooden stepladder. This was the last Boeing passenger-plane design in which the pilot sat in an open cockpit. (BA.)

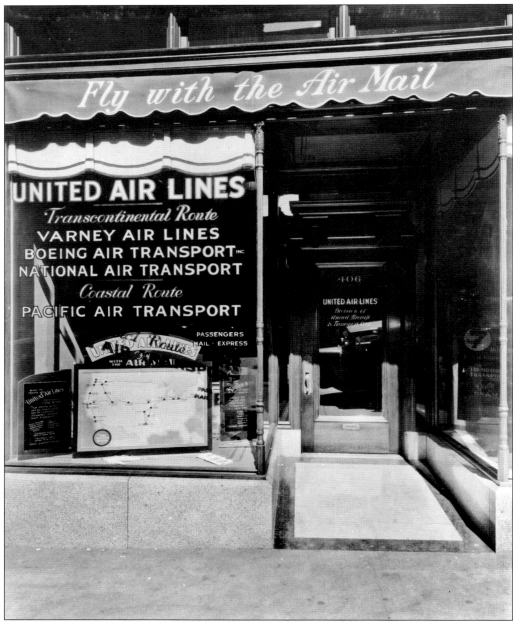

In July 1931, United Air Lines was formed as a management company to consolidate the operations of the four Boeing Group airlines. Single ticket offices were set up in major cities along the routes to handle passenger, mail, and express business. In Seattle, the office was at 406 University Street. Typically, the ticket offices could be found near major hotels, in this case across the street from Seattle's Olympic Hotel. Mainly catering to the well-to-do, airline ticket offices would continue to have a presence in the heart of most major cities for years to come. (TMOF.)

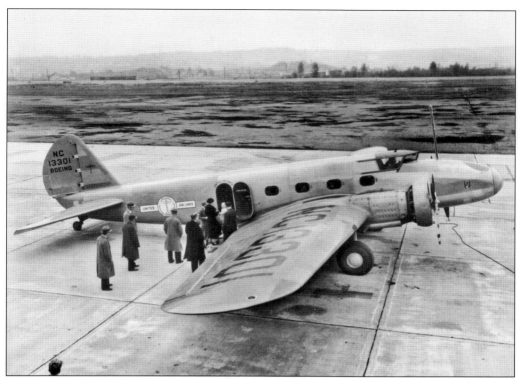

A United Air Lines stewardess welcomes Boeing Field passengers boarding the maiden commercial flight of the Boeing 247 ten-passenger airliner. The inaugural April 5, 1933, flight to Portland and points south introduced much faster service over the Pacific Air Transport Division's West Coast route. The 247s would eventually replace the Ford Tri-Motors and Boeing Model 40B-4s. (BA.)

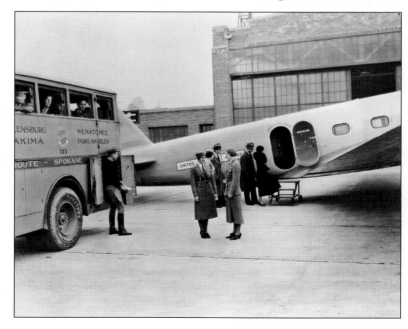

A United Air Lines stewardess and the representative for the Washington Motor Coach System compare notes while southbound passengers prepare to board the Pacific Air Transport Division Boeing 247 airliner. Passengers who arrived on the plane would take the coach to cities east of the Cascades. (BA.)

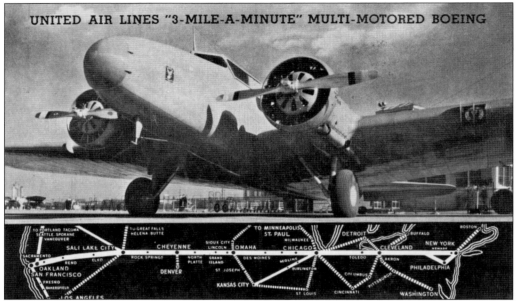

A postcard given to United Air Lines passengers introduces them to the new Boeing 247 aircraft, often referred to as the first modern airliner. The plane carried two pilots, a stewardess, and 10 passengers with their baggage, cargo, and mail. Illustrated below the plane are United's transcontinental route and the connecting flights. (EDC.)

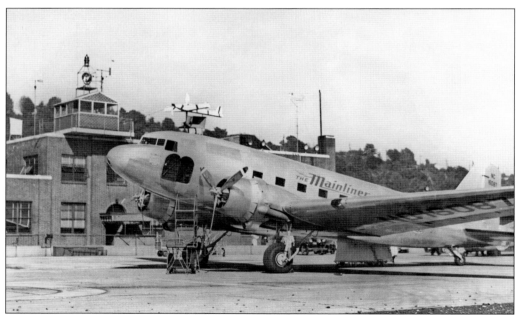

United Air Lines DC-3A-197, registered NC16087, waits on the apron at Boeing Field in December 1937. The day planes had seats for 21 passengers in one class only. They could cruise at 207 miles per hour and were powered by two Pratt and Whitney air-cooled radial engines. The open door just behind the cockpit gives access to the baggage compartment (EDC.)

50

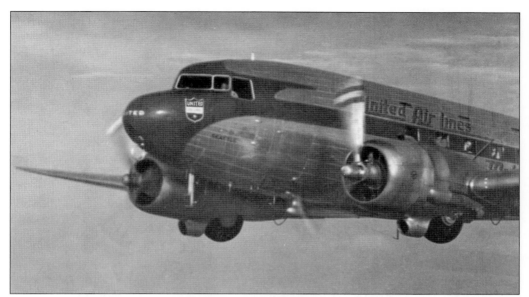

A United Air Lines postcard illustrates one of the Douglas Sleeper Transports (DST). In 1940, the company operated two daily services to Seattle from the Midwest and East Coast. During the night, the aircraft seats could be reconfigured with 14 single beds. The DST on the postcard is named *Mainliner Seattle* and is configured in the streamlined red, blue, and polished aluminum livery introduced in 1940. (EDC.)

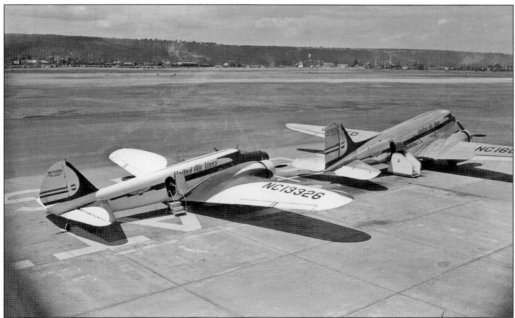

Two classic airliners, a Boeing 247D (left) and a Douglas DC-3A (right), are parked on the ramp at Boeing Field in 1940. The 247D is in United's new red, white, and blue livery. It was originally delivered to National Air Transport in May 1933. NC16070 was United's first DC-3, delivered in November 1936. It is on display at the Evergreen Aviation and Space Museum in McMinnville, Oregon. (EDC.)

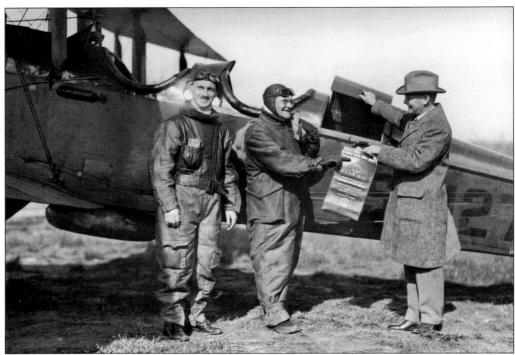

The CAM 5 route between Pasco, Washington, and Elko, Nevada, was awarded to Walter T. Varney, who inaugurated the service on April 6, 1926. Seattle postmaster C. M. Perkins (center) is photographed accepting a pouch of mail to be flown on this first service from Dr. Lyle Spencer of the Seattle Chamber of Commerce. On the left is Lt. T. K. Matthews, pilot of the DH-4 they would fly to Pasco. (MOHAI-P.)

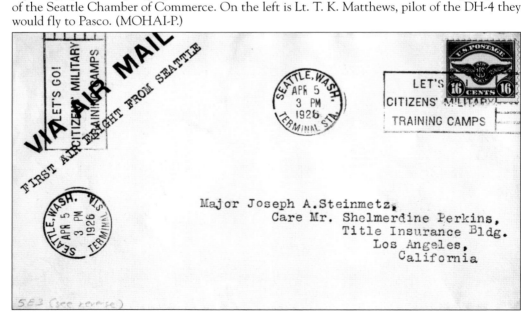

This letter probably was carried by train from Seattle to Pasco, then placed aboard the first CAM 5 flight to Elko. From there, it was transferred to the post office's transcontinental airway to San Francisco, then by train to Los Angeles. Note the early, very expensive postage stamp. (EDC.)

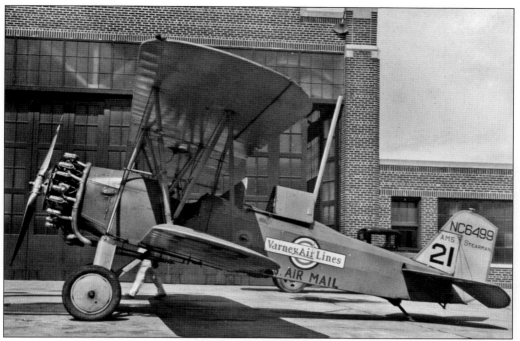

This Varney Air Lines Stearman C-3B Special appeared at Boeing Field around 1930. Varney was the successful bidder for CAM 32 between Seattle and Pasco. This route and Varney's Pasco to Salt Lake City, Utah, route were consolidated during 1930, becoming CAM 5 as noted on the tail of the aircraft. The number "21" is the fleet number, actually the 20th aircraft because "13" was not used. (TMOF.)

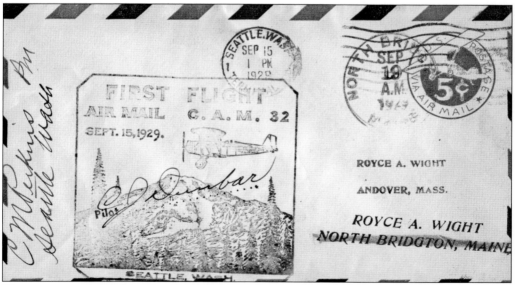

This cover was flown from Seattle to Pasco on the first flight of CAM 32, then on to Salt Lake City, connecting there with the transcontinental airmail route to the East Coast. C. M. Perkins, Seattle's postmaster, and C. Dunbar, the mail plane's pilot, have both signed the cover. Boeing purchased Varney in 1930. (EDC.)

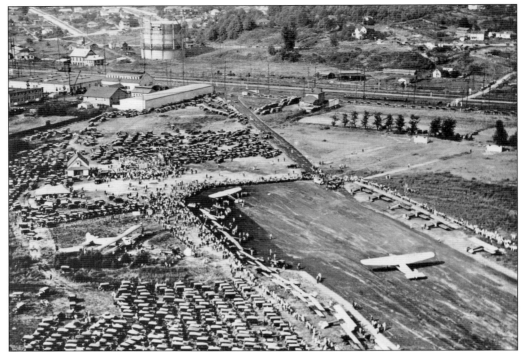

This aerial view of the dedication of Seattle's Boeing Field in July 1928 includes three tri-motor transports—the first Boeing Model 80 (left), a West Coast Air Transport Bach Air Yacht (center), and a British Columbia Airways Ford Tri-Motor (right). The Ford crashed in Puget Sound a few weeks later, killing all seven on board. (BA.)

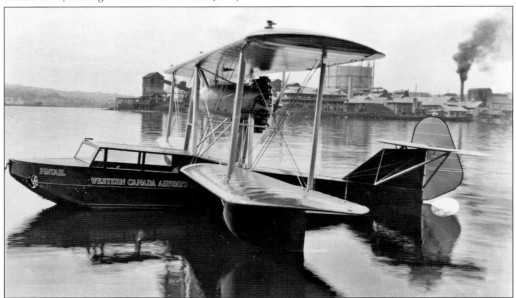

In 1931, Western Canada Airways briefly offered flying-boat service between Seattle, Vancouver, and Victoria. The company operated Boeing Model 204s, one of which is shown here at the terminal on the east side of Lake Union. Boeing's British Columbia subsidiary built several 204s. (TMOF.)

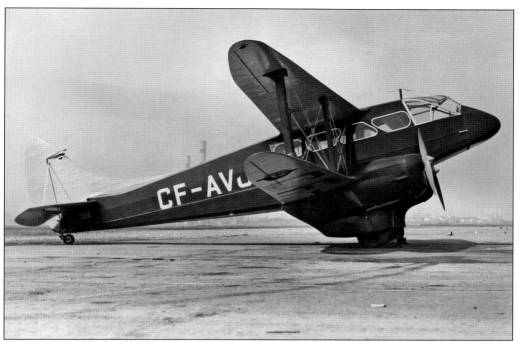

A Canadian Airways Limited (CAL) de Havilland D.H. 84 Dragon waits for passengers and mail at Seattle's Boeing Field with the smokestacks of the Georgetown steam plant in the background. This aircraft was later replaced by a larger 10-passenger Lockheed Model 10-A Electras that had a sparkling top speed of 190 miles per hour. CAL's mail contract and aircraft were acquired by Trans Canada Airlines on September 1, 1937. Electra CF-TCC operated that airline's first commercial service, on a scheduled flight to Seattle. (TMOF)

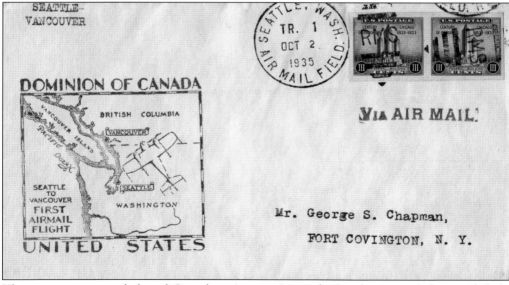

This cover was carried aboard Canadian Airways Limited's October 2, 1935, first mail flight between Seattle and Vancouver. The inaugural southbound service arrived at Seattle the previous day on the de Havilland Dragon flown by pilot E. P. Wells (EDC.)

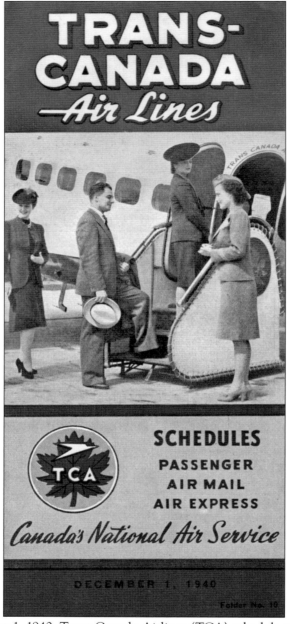

When this December 1, 1940, Trans Canada Airlines (TCA) schedule was issued, two daily round-trips were being flown between Vancouver and Seattle with connecting flights in Seattle to Portland, San Francisco, and Los Angeles on United Air Lines. There was only one class of travel. The hour flight between Vancouver and Seattle cost $14.20 round-trip. It was hardly an accident that newly formed Trans Canada in 1937 used its first flight to serve Seattle and Vancouver, British Columbia. Philip Johnson, who had been forced by the U.S. government to leave Boeing and United Air Lines after congressional hearings in 1934, resumed his distinguished aviation career in Canada as TCA's first vice president for operations. He returned to Boeing to manage aircraft production during World War II. Sadly, he died before the war ended. (EDC.)

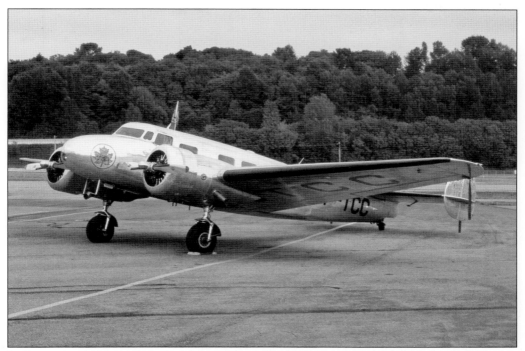

In September 2007, a refurbished former Trans Canada Airways Lockheed Model 10-A Electra, CF-TCC, returns to Boeing Field. The flight to Seattle celebrated the 70th anniversary of TCA's first commercial flight, operated from Vancouver to Seattle by this same plane. (ED.)

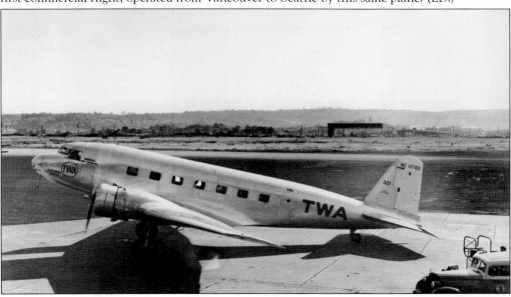

During 1938, Transcontinental and Western Air, Inc., (TWA) advertised a connecting service between Boston, New York, Chicago, and Seattle in conjunction with United Air Lines and Northwest Airlines. However, it is unclear why this 14-passenger TWA DC-2 was at Boeing Field in Seattle when it was photographed in 1938. The airmail number on the nose indicates that it normally flew on the Newark, New Jersey, to Los Angeles route. (EDC.)

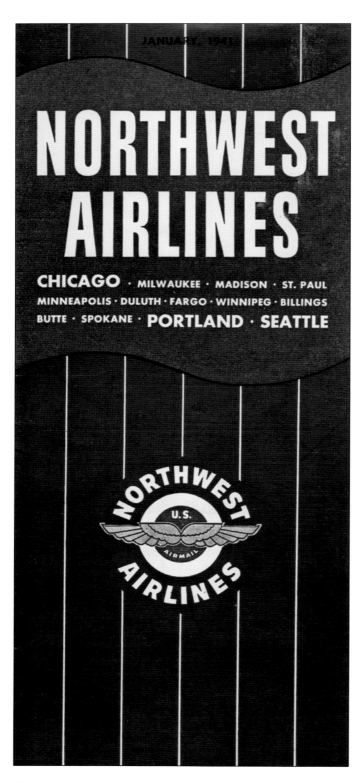

Northwest Airlines' January 1941 timetable announces the "fastest route between Seattle and Chicago." Three fast flights left Seattle—the Sunlighter at 8:15 in the morning, Twilighter at 4:35 in the afternoon, and Starlighter at 8:30 in the evening. All used 21-passenger Douglas DC-3s. Round-trip fare for the journey was $160, and it took 12 hours (one way) to arrive. Northwest began service across the northern part of the country as Northwest Airways. Congressional hearings in 1934 questioned the propriety of mail contracts awarded in 1930. Consequently, companies that were allowed to resume carrying the mail were reorganized. Northwest thus became Northwest Airlines and would be known as such until merging with Delta. (EDC.)

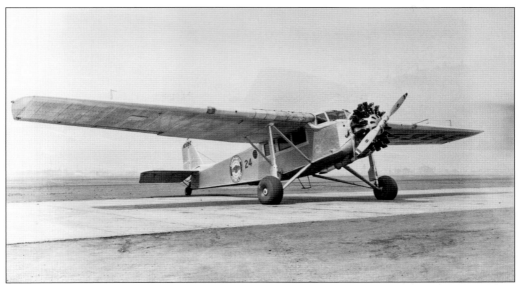

Northwest Airlines was among the first to utilize the six-passenger Hamilton H-37 with its 525-horsepower Pratt and Whitney Hornet engine. Northwest operated the first northern-tier airmail route from Chicago to Seattle beginning in the early 1930s. This all-metal Hamilton, seen here at Seattle's Boeing Field, was one of about 20 built by the Milwaukee, Wisconsin, company founded by Tom Hamilton in Seattle 20 years earlier. (TMOF.)

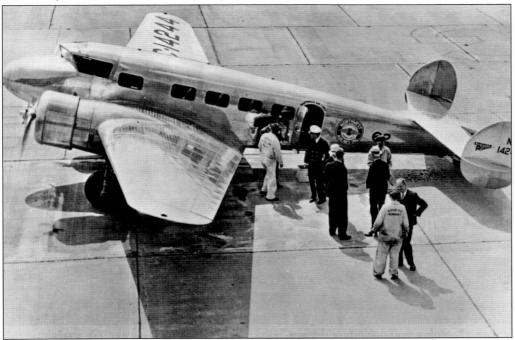

In August 1934, Northwest Airlines became the first carrier to fly the 10-passenger Lockheed Model 10 Electra in scheduled service. Initially, Northwest operated Electras between Seattle and Billings, Montana. Above, passengers board one of Northwest's Electras at Boeing Field, operated by King County. A county employee (in white overalls) stands by to assist. (MOHAI.)

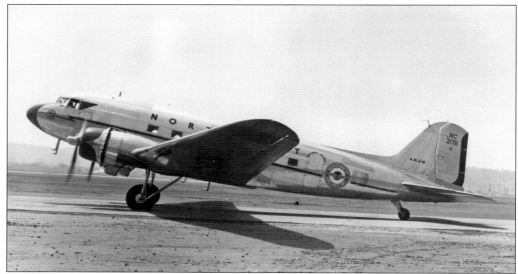

NC21711 was delivered to Northwest Airlines, Inc., in April 1939, the first of its fleet of DC-3As. It is shown at Boeing Field during the same year. The numbers on the vertical stabilizer indicate that it was being flown between Chicago and Seattle, carrying passengers and mail over CAMs 3 and 16. Flying for another operator, this aircraft crashed and was destroyed in Indonesia in August 1972. (EDC.)

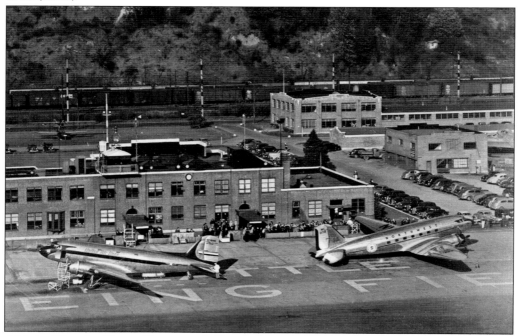

A United Douglas Sleeper Transport (left) and the Northwest DC-3A in front of the Boeing Field terminal are parked tail to tail because the passenger door on the United plane is on the right side; the Northwest DC-3 has the door on the left side. NC18145 is a 14-passenger transcontinental Douglas Sleeper Transport identified by the tiny rectangular windows of the upper sleeping berths. (TMOF.)

Visitors attending the dedication of Seattle's Boeing Field in July 1928 inspect the West Coast Air Transport Bach Air Yacht *Crusader*. The *Crusader* was the first of more than 20 air yachts built by the Bach Aircraft Company in Southern California. One 220-horsepower Wright J5 and two 125-horsepower Siemens-Halskes engines powered the *Crusader*. (TMOF.)

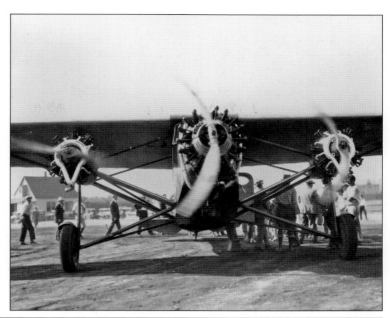

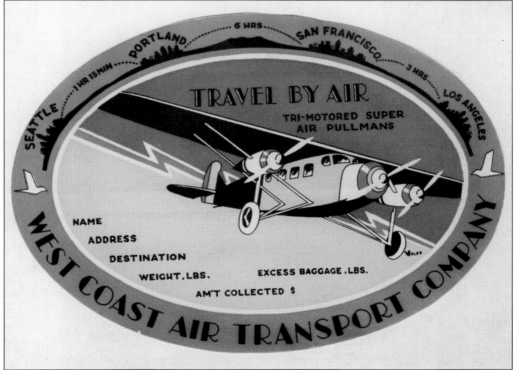

This West Coast Air Transport baggage sticker depicts the airline's route and its aircraft, the Bach Air Yacht, which carried eight passengers and two crew members. In March 1928, West Coast Air Transport became the first carrier to feature multiengine aircraft service between Seattle and San Francisco. Before Boeing Field opened, West Coast flew in and out of Renton's Bryn Mawr Airport. (TMOF.)

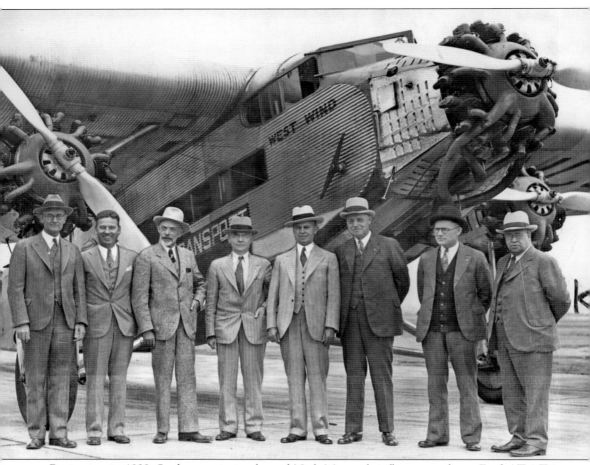

Beginning in 1929, Spokane aviation legend Nick Mamer briefly operated two Ford AT-4 Tri-Motors as part of Mamer Air Transport. Dignitaries from Spokane and Seattle gather next to the *West Wind* at Boeing Field. Using Spokane as a hub, Mamer had extended service eastward to Minneapolis by 1930. Unable to secure a mail contract, he sold out to Northwest Airlines. Flying for Northwest as chief pilot in 1938, Mamer was killed, along with his copilot and eight passengers, when their Lockheed Model 14-H Super Electra broke up over Montana. (WLC.)

Three

LOCAL OPERATORS AND OUTSIDERS

The combination of Charles Lindbergh's heroic nonstop flight from New York to Paris in May 1927, along with the federal money flowing into commercial aviation via the contract airmail routes, sparked interest, innovation, and entrepreneurship in the late 1920s. In the early 1930s, as the economy collapsed in the Great Depression, aviation enterprises around the country failed. Despite a difficult business climate in Seattle, individuals like Percy Barnes, Vern Gorst, Elliott Merrill, Gill Cook, Lana Kurtzer, and Jim Galvin persevered.

Bigger and more powerful aircraft, as well as demand for aviation services in terms of private aircraft, flying lessons, and scheduled and short-haul services, also led to more and better airfields. Boeing Field opened in July 1928. Companies used wooden hangars there before the passenger terminal began serving the public in April 1930. Large brick hangars followed in the next few years. In Renton, Northwest Air Service operated a seaplane facility and landing strip at Bryn Mawr on the southwest shore of Lake Washington at the mouth of the Cedar River. Seaplane activity on Lake Union flourished. By the start of World War II, Lake Union would boast two busy seaplane terminals. Kent, which had been the site of George Takasou's first flights in 1911 and Herb Munter's brief operation in 1920, gained a permanent airfield when the Becvar brothers set up shop in 1928.

Improved engines allowed manufacturers greater flexibility in their designs. Companies like Bellanca, Fairchild, Stinson, and Waco focused on single-engine aircraft. They preferred to upgrade proven models rather than embark on radical changes. In the challenging marketplace of the 1930s, who could blame them? Meanwhile, the airplane became increasingly popular as a marketing tool. The major oil companies, in particular, established national aircraft fleets. These airplanes, in flashy company colors, visited airports, including Boeing Field, to promote their products and gain market share.

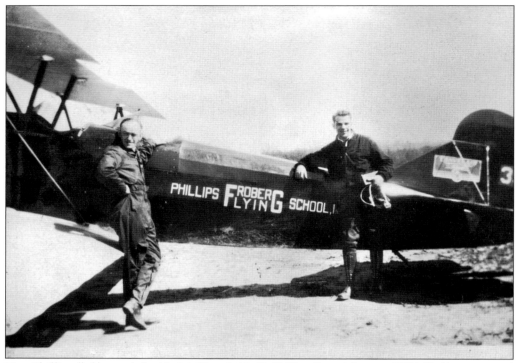

Don Phillips (left) stands beside his Travel Air C-4000 at Bryn Mawr in 1928. Phillips operated a flight school and flying service first at Bryn Mawr and later at Seattle's Boeing Field. He successfully competed in regional air races and later helped pioneer regular passenger flight across the Cascades. The Travel Air C-4000 featured the 170-horsepower Curtiss Challenger, later upgraded to 185 horsepower. (TMOF.)

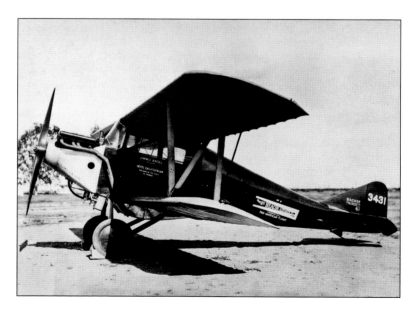

In April 1928, the only Bach CS-4 with its 150-horsepower Hispano-Suiza engine waits at Bryn Mawr after arriving in the Seattle area from California. With promising orders from airlines, the Bach Aircraft Company dropped further production of the CS-4 in favor of the larger Bach Air Yacht. (TMOF.)

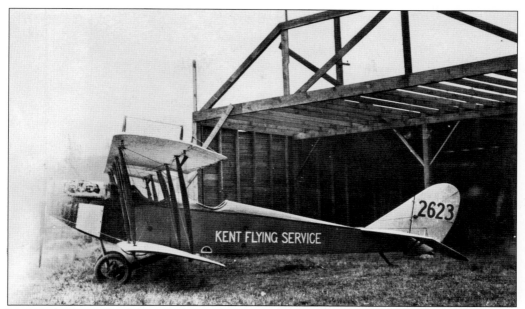

In 1928, the Becvar brothers started Kent Flying Service with this World War I–surplus Curtiss JN-4H. The H model boasted the 150-horsepower Hispano-Suiza engine, a significant upgrade over the 90-horsepower Curtiss OX-5 found on earlier models. Sold as surplus in the 1920s, the Jenny became popular with entrepreneurs who toured the country or operated out of small fields. (TMOF.)

George, the oldest of the three Becvar brothers, and his Waco 10, powered by a 90-horsepower Curtiss OX-5 engine, wait for a passenger or student pilot near the hangar of the family's Kent Flying Service south of Seattle. In the early 1930s, Becvar halted operations and went to work for Boeing. (TMOF.)

AT THE

KENT THEATRE
SUNDAY & MONDAY
FEBRUARY FIFTH and SIXTH

DISTRIBUTED BY

KENT FLYING SERVICE
Safety — Satisfaction — Speed

NOTE: If you find one of these bills printed in red ink, present it Sunday afternoon between 2.30 and 5.00 o'clock and you will get in FREE. There have been one hundred of the red ones printed.

SPONSORED BY

KENT THEATRE & THE KENT VALLEY NEWS

EAGER TO SERVE THE PUBLIC —
— DEVOTED TO YOUR INTERESTS

This handbill describes a coming attraction. The Kent Flying Service dropped these over Kent and Auburn, south of Seattle, in February 1928. Note the reference to the flying service on the leaflet. Depending on whether one might consider this litter, such a reference might leave a negative, rather than positive, impression. *Now We're in the Air*, like several other Paramount films, borrowed footage from *Wings*, the World War I saga that won the first Academy Award for Best Picture. With the success of *Wings*, Hollywood produced a number of World War I flying flicks, including the Howard Hughes epic, *Hell's Angels*. (TMOF.)

In April 1929, George Becvar (left) and parachute jumper Al Brown meet enthusiasts before taking to the air to thrill the crowd at Kent Flying Service's airfield south of Seattle. Brown jumped without incident, but another parachutist, Bill Hatfield, landed awkwardly and briefly knocked himself unconscious that afternoon. (TMOF.)

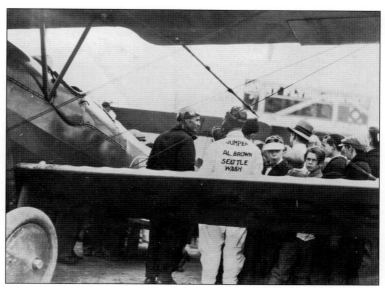

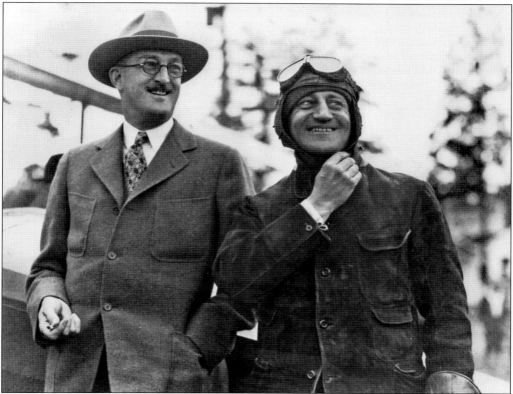

William Boeing (left) greets Thomas Simpson, National Aeronautical Association governor for the state of Washington, at Sand Point in June 1928. Simpson flew his Stearman C-3B with its 220-horsepower Wright J5 engine to San Diego and back, the first private flyer to complete such a trip. Simpson contributed to aviation progress throughout the state before dying in a crash in Eastern Washington in 1931. (BA.)

One of Seattle Flying Service's Travel Air 2000s, with its 90-horsepower Curtiss OX-5 engine, is ready for business at Boeing Field. Vern Gorst started the Seattle Flying Service after selling Pacific Air Transport to Boeing Air Transport in early 1928. After Boeing Field opened in July 1928, Gorst moved the Seattle Flying Service from his airfield west of the Duwamish River to Boeing Field. (TMOF.)

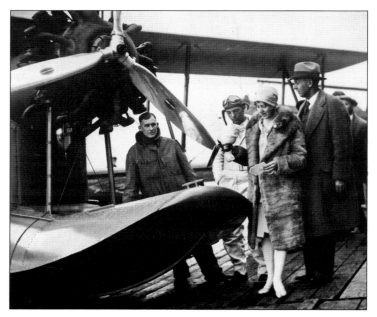

In June 1929, Fern Naylor (second from right) and Vern Gorst (far right) inaugurate Gorst Air Transport service between Seattle and Bremerton using a Loening Air Yacht powered by a 525-horsepower Wright Cyclone engine. To the left are pilots Percy Barnes (far left) and Clayton Scott. Originally designed for the U.S. Army, the Loenings proved popular with airlines before Sikorsky dominated the amphibian market. (TMOF.)

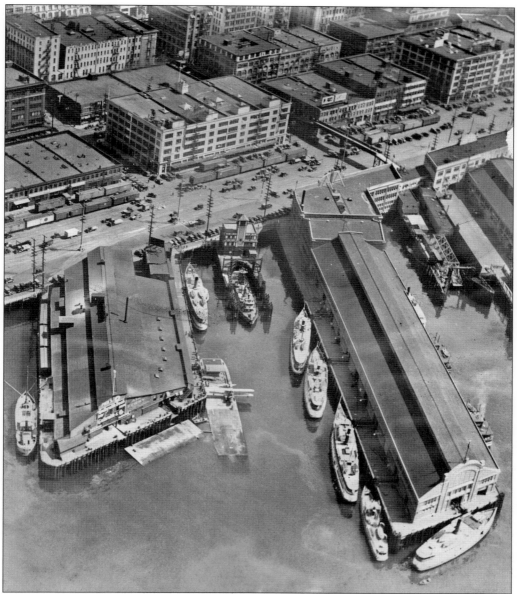

A Gorst Air Transport Loening Air Yacht is parked on the boarding ramp to the right of Pier 3 in downtown Seattle in the latter half of 1929. The Loenings were the first amphibian aircraft used commercially in Seattle. Capable of carrying seven passengers and a pilot, the aircraft proved ideal for the short run between Seattle and Bremerton. One of these planes crashed departing Bremerton in late 1929, killing pilot Don Monroe and mechanic Al Van Vleet. The cause of the crash was believed to be the failure of the horizontal stabilizer after a fastener came loose. (TMOF.)

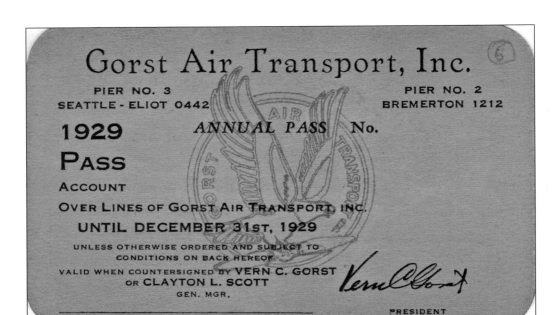

Gorst Air Transport, Inc.

PIER NO. 3
SEATTLE - ELIOT 0442

PIER NO. 2
BREMERTON 1212

6

1929
PASS

ANNUAL PASS No.

ACCOUNT

OVER LINES OF GORST AIR TRANSPORT, INC.

UNTIL DECEMBER 31st, 1929

UNLESS OTHERWISE ORDERED AND SUBJECT TO
CONDITIONS ON BACK HEREOF

VALID WHEN COUNTERSIGNED BY VERN C. GORST
OR CLAYTON L. SCOTT
GEN. MGR.

Vern C. Gorst

PRESIDENT

Frequent flyers could save money purchasing an annual pass on Gorst Air Transport. Vern Gorst originally charged $2.50 for the one-way trip between Bremerton and Seattle before eventually lowering it to $2. Gorst's service prompted the Black Ball Line ferry company to increase the number of daily sailings. (TMOF.)

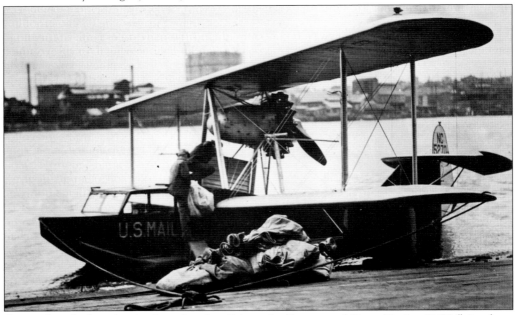

An unidentified worker loads sacks of mail into the Barnes and Gorst Boeing B-1E flying boat before it departs from Seattle's Lake Union for Victoria, British Columbia. After Vern Gorst purchased the smaller B-1D, he had Boeing lengthen the fuselage and replace the original 220-horsepower Wright J5 Whirlwind with a 450-horsepower Pratt and Whitney Wasp found on all other E models. (TMOF.)

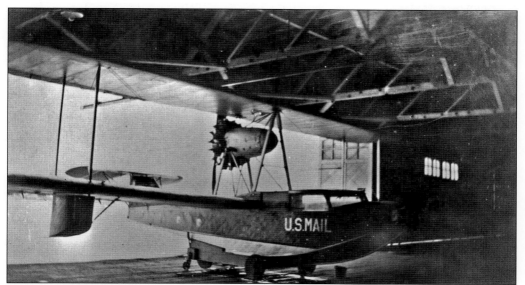

To support the airmail route to Victoria, Vern Gorst leased the seaplane terminal at the foot of Roanoke Street on the east shore of Seattle's Lake Union. Gorst purchased the first of two Boeing flying boats, the B-1D *Zephyr* (pictured above), in April 1928. His partner, Percy Barnes, did most of the flying and took responsibility for maintenance. They equally shared the revenue. (TMOF.)

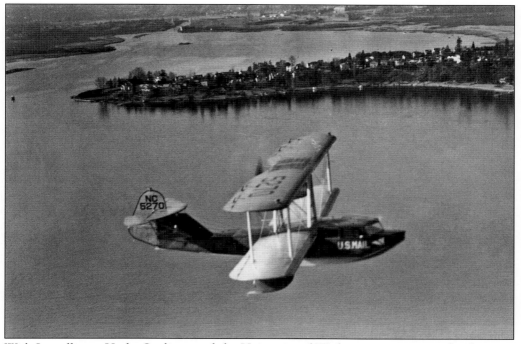

With Laurelhurst, Husky Stadium, and the University of Washington campus in the distance, the Barnes and Gorst Boeing B-1E flies over Lake Washington. The B-1E proved to be a real workhorse for Barnes and Gorst, which typically made three round-trips a week between Seattle and Victoria, British Columbia. (TMOF.)

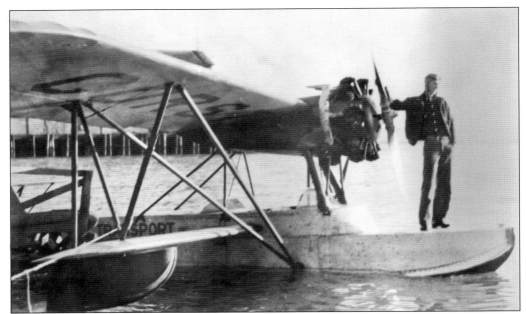

On the Elliott Bay waterfront, an unidentified pilot from Seattle Flying Service waits on the bow of an Eastman Sea Rover, which was powered by a 185-horsepower Curtiss Challenger engine. In 1931, Vern Gorst bought this Sea Rover, with its four-passenger capacity and dual controls, for short-range charters and flight instruction. (TMOF.)

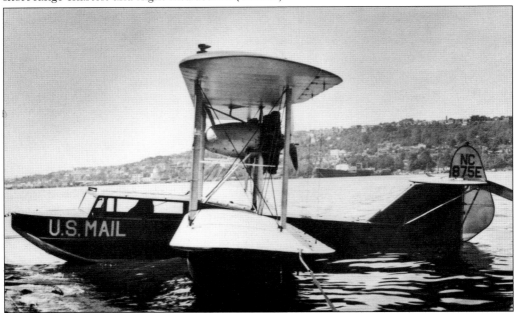

The Boeing Airplane Company's B-1E and Model 204 flying boats were virtually identical aircraft. Both carried six passengers and were powered by a 450-horsepower Pratt and Whitney Wasp engine. This B-1E shown here on the east side of Seattle's Lake Union served as William Boeing's personal plane before Barnes and Gorst acquired it for use on the Seattle–Victoria, British Columbia, mail route. (TMOF.)

In the late 1920s and early 1930s, Vern Gorst operated a repair shop on Spokane Street as part of the Seattle Flying Service. Advertisements from that era described the facility as "the largest and most complete airplane repair shop in the northwest." In the background can be seen the fuselage of a Fokker F-11A amphibian. (TMOF.)

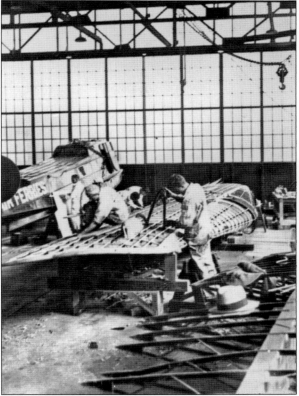

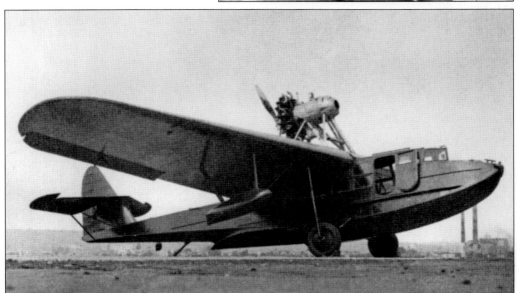

In December 1932, Vern Gorst and his son Wilbur took possession of this Fokker F-11A amphibian from defunct Air Ferries of San Francisco and flew the aircraft to Seattle's Boeing Field. Powered by a 525-horsepower Wright Cyclone engine, the 10-passenger F-11A appealed to wealthy businessmen. After Gorst sold it, the aircraft was destroyed in British Columbia in 1935. (TMOF.)

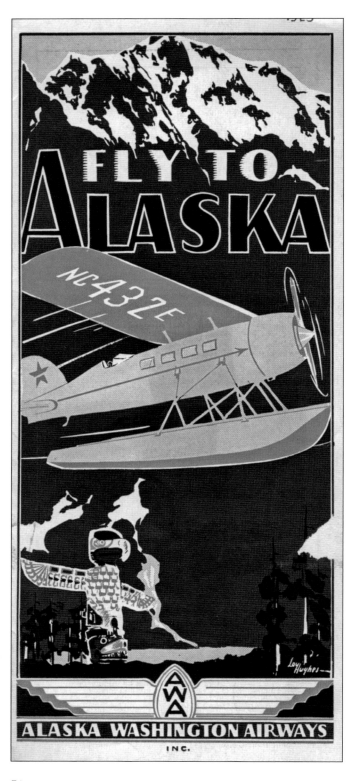

The cover of this brochure with its Lockheed Vega attempts to take business away from the steamship companies, the only practical way to get to Alaska in the late 1920s. Joseph Carman and several associates, who had successfully operated a flying school in Seattle, launched the first serious air service to Alaska by forming Alaska-Washington Airways. In the early 1930s, Alaska-Washington not only flew between Seattle and southeast Alaska, but also to British Columbia and several cities in Washington state. Without the revenue guarantee from a government mail contract, however, the company was forced to sell off all its aircraft, some of which found permanent homes in Alaska. (TMOF.)

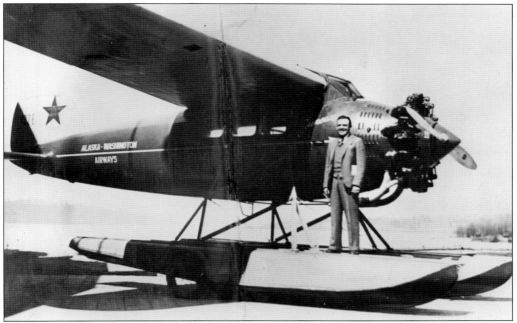

Seattle-based Alaska-Washington Airways made a big splash in April 1929 when the company's chief pilot, Anscel Eckman, shown here at Bryn Mawr, completed the first nonstop flight from Seattle to Juneau. Eckman made the trip in this Lockheed Vega 5B, powered by a 450-horsepower Pratt and Whitney Wasp engine. (MOHAI.)

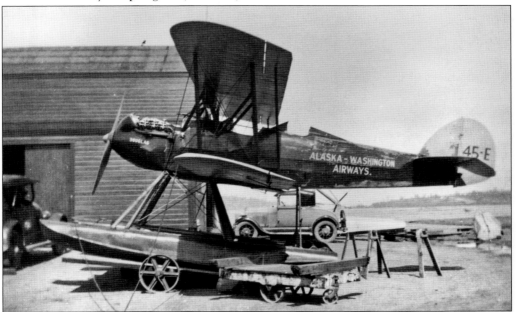

This Waco 10 possibly waits for repairs at Bryn Mawr, southeast of Seattle. Alaska-Washington Airways briefly owned this aircraft, which previously had been operated by the Aviation School at Boeing Field in the late 1920s. First flown in 1927, the extremely popular Waco 10 was frequently used for flight instruction. (TMOF.)

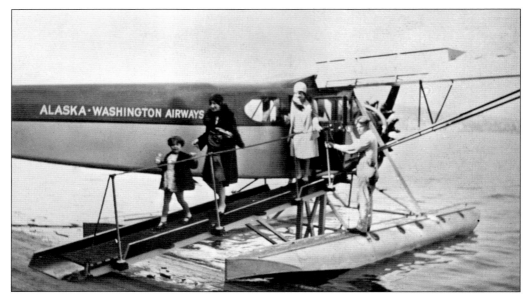

Alaska-Washington Airways continued to expand in the early 1930s by adding this Fairchild 71 to its fleet. These passengers quite possibly are arriving at Seattle's Lake Union Air Terminal from Victoria or Vancouver, British Columbia. Powered by a 420-horsepower Pratt and Whitney Wasp, the Fairchild 71 carried a pilot and six passengers. (TMOF.)

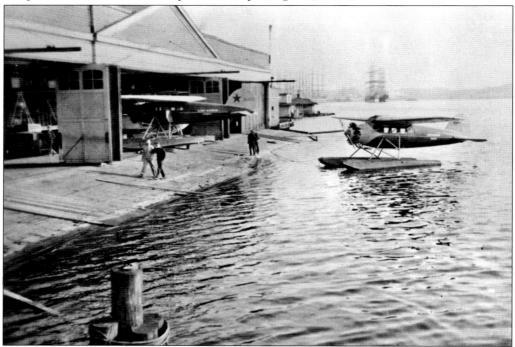

In this rare southward-looking view of Seattle's Lake Union Air Terminal, taken about 1930, Alaska-Washington Airways' two Lockheed Vega 5Bs vie for space with the two Barnes and Gorst Boeing flying boats in the hangar. With metal airplanes about to come into their own, these wooden designs signal the end of an era. (TMOF.)

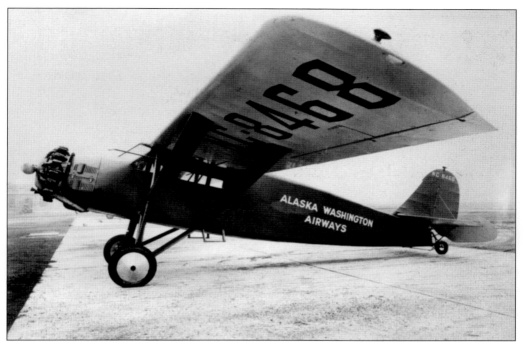

Expanding service from its Seattle hub to include inland towns like Ellensburg, Alaska-Washington Airways turned to a land plane, in this case the six-passenger Stinson SM-1 Detroiter, shown here at Boeing Field. A 220-horsepower Wright J5 engine powered the first Stinson monoplane design that proved quite popular in the late 1920s. (TMOF.)

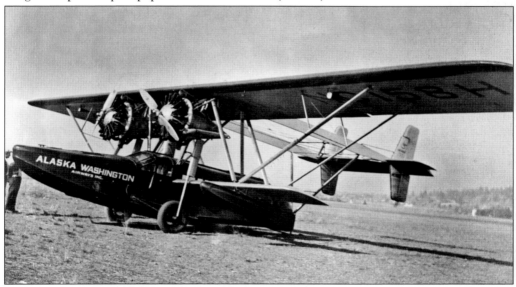

The Sikorsky S-38 Amphibion, introduced by Pan American Airways in the Caribbean in the late 1920s, offered flexibility for an operator like Alaska-Washington, which employed float and land planes from Seattle's Lake Union and Boeing Field. This S-38B, with its twin 420-horsepower Pratt and Whitney Wasp engines, later was owned and operated by famed Hollywood cinematographer Paul Mantz. (TMOF.)

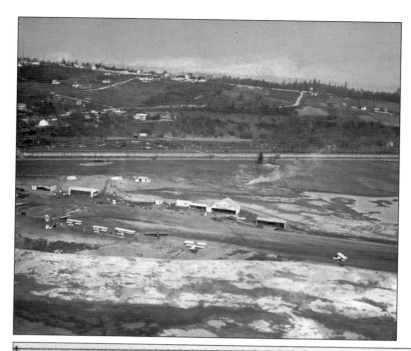

This aerial shot of Seattle's Boeing Field in June 1929 looking east shows the simple wooden-frame hangars the various aviation companies used for maintenance until the more robust brick structures were completed in the early 1930s farther south and closer to Airport Way. The terminal building opened in 1930. (MOHAI-PI.)

THUNDERBIRD

"The Wings of the Wind"

Washington and Oregon Distributors for the Thunderbird Aircraft Corp.

YOUR OPPORTUNITY
IS HERE

The rapid progress of aviation has opened this field to you. Ambitious men, visualizing the future, realize your opportunity.

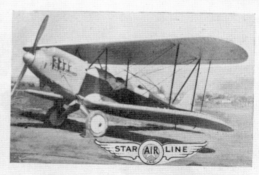

For full information covering comp'ete aviation course, write today to

STAR AIR LINE, Inc.

303 Douglas Building

SEATTLE, WASHINGTON

Star Air Line promoted its services in this advertisement in the June 1928 issue of *Pacific Airport News*. One of the first professional operations to emerge in Seattle in the late 1920s, Star actually emphasized flight training because its Thunderbird aircraft were inadequate for hauling passengers in any significant numbers. (TMOF.)

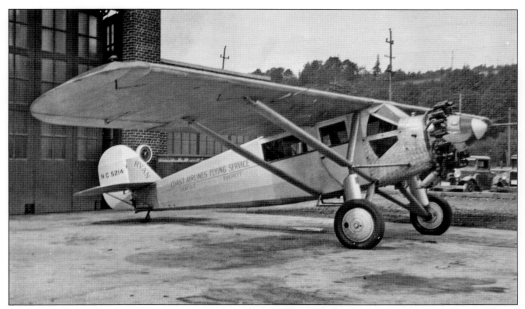

Coast Airlines Flying Service operated this Ryan B.1 Brougham out of Seattle's Boeing Field and Everett in the early 1930s. Commercial Air Transport of Everett previously used this airplane in the late 1920s before going out of business. Powered by a 220-horsepower Wright J5 engine, the B.1 evolved from the Ryan NYP, better known as the *Spirit of St. Louis*. (TMOF.)

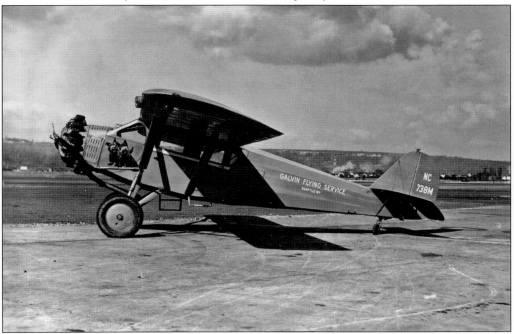

This Galvin Flying Service Ryan B.7 Brougham waits for a customer. In 1930, Jim Galvin started the company, which still bears his name, at Seattle's Boeing Field. The six-place B.7 was the last of the Brougham series. It featured the largest engine in the line, a 420-horsepower Pratt and Whitney Wasp. (TMOF.)

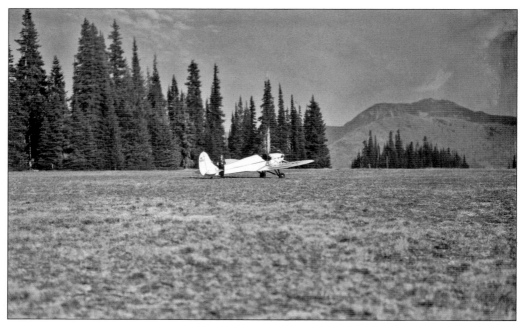

Elliott Merrill of Seattle's Washington Aircraft and Transport Company stands next to his Kinner Sportster K-100 while his anonymous passenger takes this photograph in a meadow high in Mount Rainier National Park. One of the characteristics of the Sportster, powered by a 100-horsepower Kinner engine, was its surprisingly good performance at higher altitudes. (TMOF.)

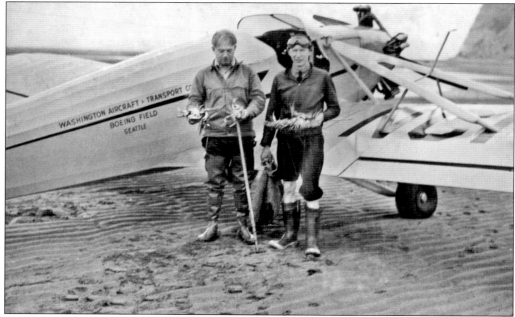

Gill Cook (left) and Elmer Hansen, two Boeing Field legends, show off crabs they have caught on a Washington beach after flying a Washington Aircraft and Transport Kinner Sportster from Seattle to the coast. In the 1930s, Cook was part owner of Washington Aircraft with Elliott Merrill at Boeing Field, while Hansen for many, many years worked as a flight instructor. (TMOF.)

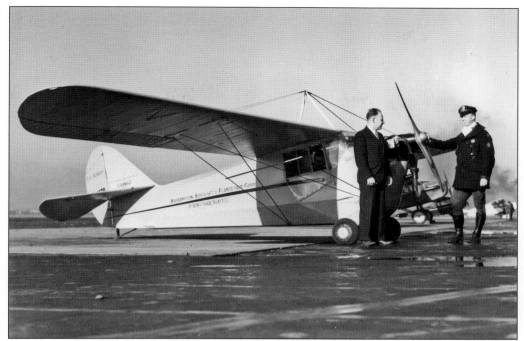

Elliott Merrill (left) and an unidentified security officer talk things over at Boeing Field in the 1930s. Merrill, who served as the first chairman of the board for the Museum of Flight, enjoyed delighting crowds at Seattle air shows by stunting in this Aeronca C-3, which was powered by a 36-horsepower Aeronca engine. (TMOF.)

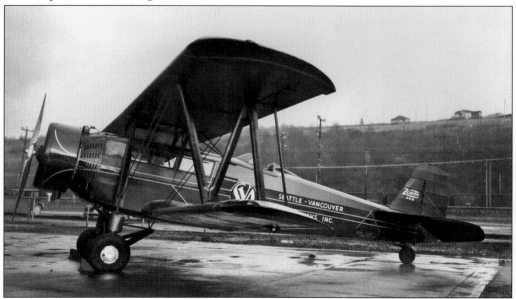

In 1932, Alaskan aviation pioneer Almer Bennett's Zenith-6B waits at Boeing Field. Bennett briefly used the Zenith, powered by a 420-horsepower Pratt and Whitney Wasp engine, to run an airline between Seattle and Vancouver, British Columbia. Bennett also operated an A model out of Boise, Idaho, as Bennett Air Transport. (TMOF.)

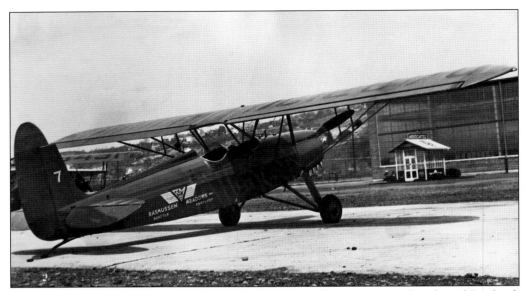

In the early 1930s, Ed Rasmussen and Les Meadows ran a flying service in Seattle and Portland, Oregon. They owned several Fairchild 22s, including this one parked at Boeing Field. The 22, with its inverted, four-cylinder, 75-horsepower Michigan-Rover engine, offered an economical option for flight schools struggling to survive during the Great Depression. (TMOF.)

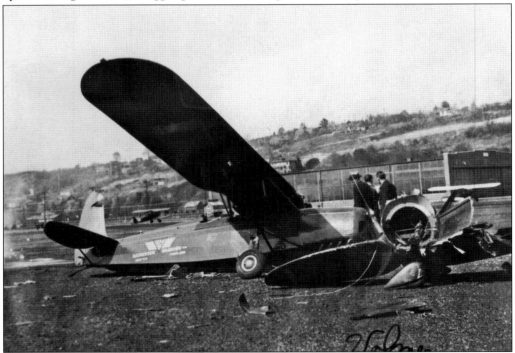

Aircraft collisions in the 1930s were relatively rare, but they happened from time to time. In this instance, a Fairchild 22 operated by Rasmussen-Meadows, Inc., has cut right through the wooden fuselage of a Shell Oil Lockheed Vega at Seattle's Boeing Field. Each aircraft carried a pilot and passenger. No one was injured. (TMOF.)

Harry Nelson, owner of Speedway Air Service, stands beside his Parks P-2A at Seattle's Boeing Field in 1933. The Parks P-2A Speedster, later known as the Ryan Speedster, evolved from a school project at Parks Air College in Illinois. This third of three versions featured a 185-horsepower Wright J6 R540 engine. (TMOF.)

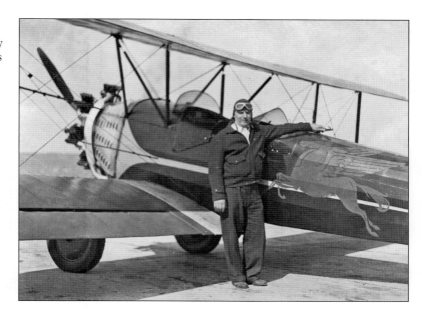

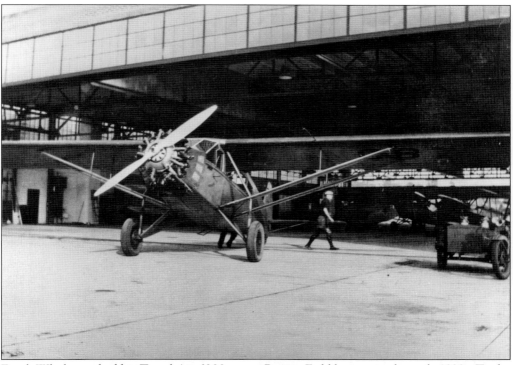

Frank Whaley parked his Travel Air 6000 near a Boeing Field hangar in the early 1930s. To the right is the motorcycle and sidecar used by airport manager Dick Miller and his predecessors. Whaley, who later moved to Alaska, worked for Speedway Air Service owner Harry Nelson. Nelson and Whaley attempted to refuel Nat Brown on his unsuccessful bid to fly nonstop from Seattle to Tokyo in the summer of 1931. (TMOF.)

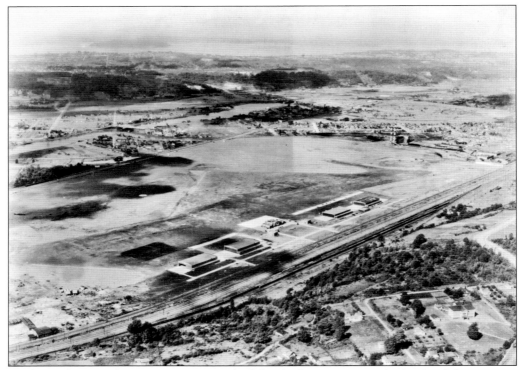

By the mid-1930s, the Austin Company had finished constructing the big brick hangars on either side of Seattle's Boeing Field terminal building. However, the facility still lacked a paved runway. The Boeing Aircraft Company's Plant No. 2 on the west side of the field remained in the future. (KCA.)

After a student cracked up his Fairchild 22, flight instructor Leonard Peterson acquired this Ryan S-T, shown here after an incident at Seattle's Boeing Field. Peterson's S-T was the first production model built and included the 95-horsepower Menasco B-4 engine. This aircraft evolved into the U.S. Army Air Forces' PT-22 primary trainer. (TMOF.)

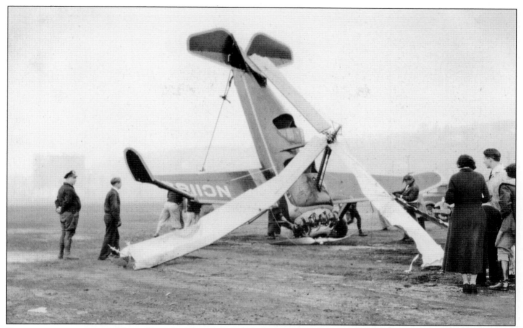

Spectators surround King Baird's Pitcairn PCA-2 Autogiro at Seattle's Boeing Field in the early 1930s after a mishap at an air show. Baird, a successful automobile dealer, dabbled in aviation in the 1930s. His Puget Sound Airways briefly utilized the novel Autogiro. A 300-horsepower Wright J6-9 engine powered this model. (RWE.)

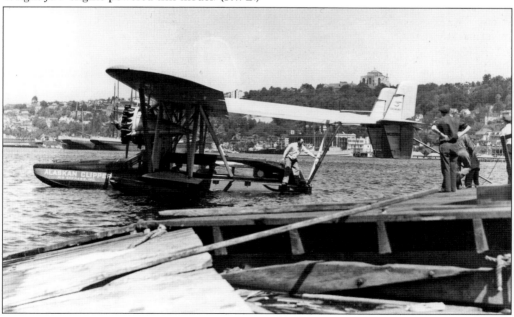

In the summer of 1936, King Baird tried unsuccessfully to break into the Seattle-Alaska market by using the *Alaska Clipper*, a Sikorsky S-38C Amphibion, shown here at the south end of Lake Union, as the main aircraft for Air Express, Inc. The C carried two more passengers than the B but over a shorter distance. (TMOF.)

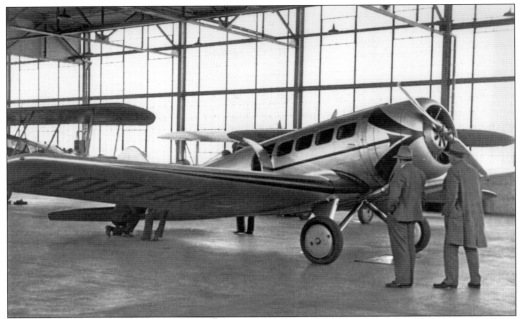

The second Northrop Alpha 2 attracts attention in one of the hangars at Seattle's Boeing Field in 1931. At the time, Northrop was part of the United Aircraft and Transport Corporation, of which William Boeing was president. Perhaps the observers are Boeing engineers whose future thoughts about all-metal airplanes may be influenced by Jack Northrop. (TMOF.)

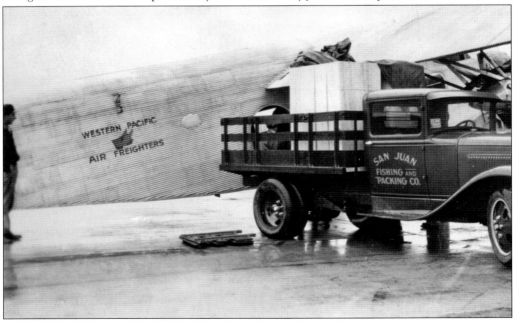

A worker transfers seafood from a Ford Tri-Motor to a San Juan Fishing and Trading Company truck at Boeing Field. In the 1930s, San Juan was a major seafood processor with a nearby plant on Seattle's Duwamish waterway. As newer aircraft replaced the Fords as airliners, they became freight haulers. (RWE.)

86

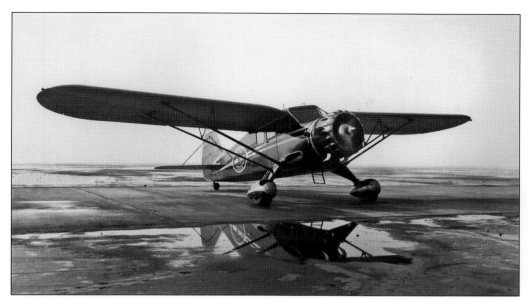

A Stinson SR-5E Reliant promoting Aero Struts, an Ohio-based company known for its landing gear, visits Seattle's Boeing Field. The Stinson Reliant series with its distinctive gull wing proved to be popular. The 450-horsepower Pratt and Whitney Wasp engine powered this version of the Reliant. (TMOF.)

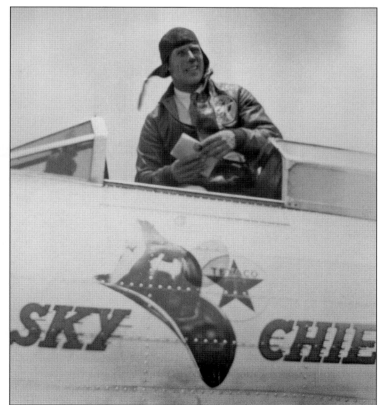

Veteran racing pilot Frank Hawks greets a crowd at Seattle's Boeing Field in 1933. Hawks, director of aviation for Texaco, toured the country in the company's Northrop Gamma 2-A with its 700-horsepower Wright engine. Texaco dubbed the aircraft *Sky Chief* and later used that name to brand its premium gasoline. (TMOF.)

SECOND ANNUAL SEATTLE AIR SHOW

Boeing Field—Sunday, 1 P. M.

September 9, 1934

Sponsored by

Seattle
Junior Chamber of Commerce

PROGRAM

1:00 P. M. Parade of Planes

1:15 P. M. Transport Plane Arrival

1:30 P. M. Transport Plane Departure

1:35 P. M. Small Plane Race (Limited to 125 H. P.)

1:50 P. M. Men's Puff Race

2:10 P. M. Puddle Jumper Handicap

2:30 P. M. Large Plane Race (Limited to 225 H. P.)

2:45 P. M. Special Event

3:00 P. M. Women's Puff Race

3:15 P. M. Men's Dead Stick Landing Contest

3:45 P. M. Hal Wilson (Stunt Flying)

4:00 P. M. Women's Dead Stick Landing Contest

4:30 P. M. Gladys Vickers (Special Acrobatics)

JUDGES

W. W. CONNOR ROYAL BROUGHAM

LT. R. C. MANGRUM

LOUD SPEAKER SYSTEM FREE HANGAR STORAGE

Courtesy of Courtesy of

UNION OIL COMPANY BOEING FIELD

PRIZES

Presented by

STANDARD OIL CO. ASSOCIATED OIL CO.

PENZOIL CO. TEXACO CO.

UNION OIL CO. SHELL OIL CO.

This program outlines the highlights of an upcoming air show. During the grim economic times of the 1930s, Seattle residents flocked to Boeing Field to enjoy the diversion offered by the annual air show. Interesting aircraft arrived from around the Pacific Northwest as flyers competed in various contests. When it came to stunt flying, Tex Rankin of Portland, Oregon, ranked among the nation's greats. Cora Sterling, at the time, was among the youngest licensed women pilots in the country. Sterling and four small girls died in a crash at Boeing Field while returning from a sightseeing flight in 1940. (TMOF.)

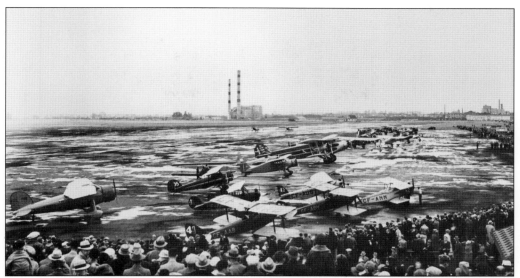

Airplanes and crowds gather at Seattle's Boeing Field for the city's second annual air show in 1934. The large aircraft in the middle, a Boeing Model 226, belongs to Standard Oil of California. In the 1930s, competition among the oil companies was fierce. Six different firms helped sponsor the air show. (TMOF.)

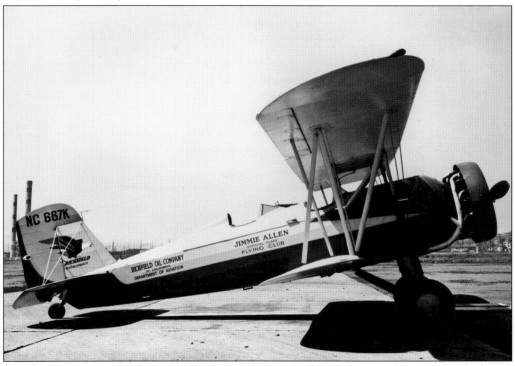

Speedy Stearman aircraft, originally designed to carry the mail, proved popular with the oil companies. The Richfield Oil Company operated this Stearman 4-E, with its 450-horsepower Pratt and Whitney Wasp engine, in the 1930s. Stops included this one at Seattle's Boeing Field, possibly to give fans of the Jimmy Allen radio show rides as part of a promotion. (TMOF.)

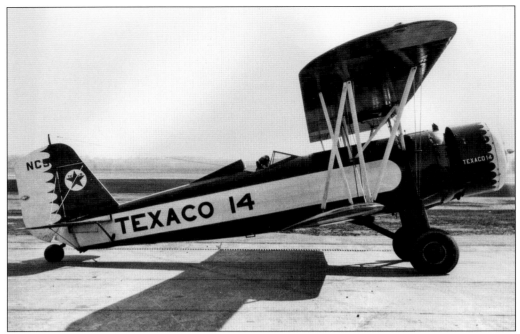

Texaco operated a fleet of aircraft, including this Stearman 4-D, seen here at Seattle's Boeing Field. The 4-D was the first certificated airplane equipped with the new 300-horsepower Pratt and Whitney Wasp Junior engine. Pratt and Whitney acquired the first 4-D and Texaco the second when the aircraft appeared in 1930. (TMOF.)

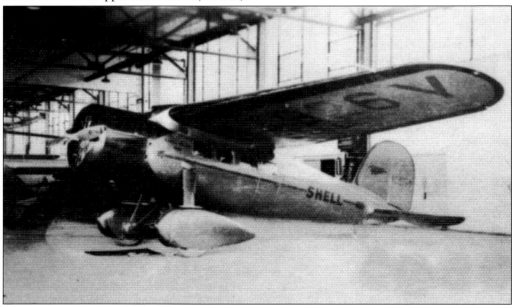

One of Shell's Lockheed Vega 5Cs, with its 450-horsepower Pratt Whitney engine, waits in a hangar at Boeing Field in Seattle. Like Texaco, Shell also operated many aircraft, at one point nearly a dozen simultaneously. This particular Vega served as the official "press plane" at the 1933 national air races in Cleveland, Ohio. (TMOF.)

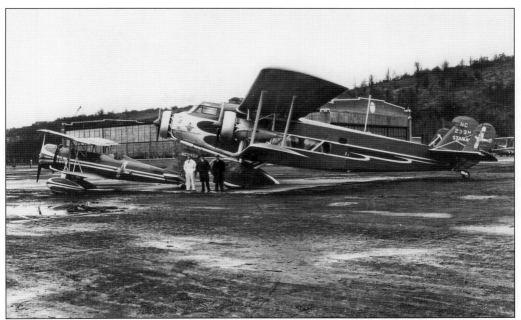

The Standard Oil of California Boeing Model 226 returns to Seattle's Boeing Field in 1931. Originally conceived as a Boeing Model 80A, this aircraft underwent extensive interior modifications that reduced its passenger capacity but transformed it into a corporate airliner. To the left of the Model 80 is a Standard Oil Stearman 4-E. (BA.)

Standard Oil of California's Boeing Model 40Y takes on fuel at Seattle's Boeing Field about 1930. The 40Y, like the 40X sold to Associated Oil, featured two open cockpits, the second replacing one of the two passenger compartments, but it had the larger 525-horsepower Pratt and Whitney Hornet engine, cowling, and wheel pants. (BA.)

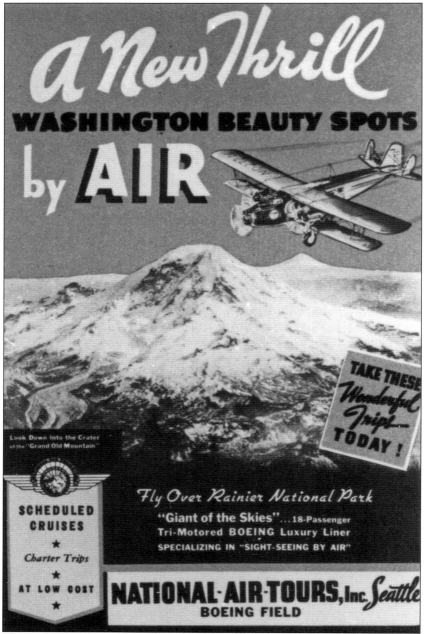

Brochures like this one promote National Air Tours, Inc., based at Boeing Field. In the mid-1930s, longtime Northwest pilot Lonnie Brennan acquired a Boeing Model 80A-1 after United Air Lines had replaced that series of aircraft with the Boeing Model 247. In the late 1920s, Brennan worked for Vern Gorst's Seattle Flying Service. He then moved to Spokane and flew Ford Tri-Motors for Nick Mamer's Mamer Air Transport. From Spokane, he went to Alaska for a few years before returning to Seattle to operate National Air Tours. With its 18-passenger capacity, the Model 80A-1 probably was a larger aircraft than Brennan really needed during the tough times of the Depression. (TMOF.)

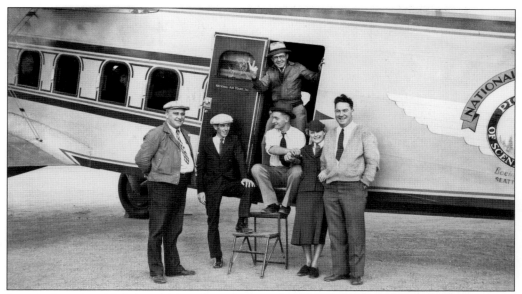

Lonnie Brennan (right) and his wife and stewardess, Lyndy Neil, gather with the National Air Tours crew and the company's Boeing Model 80A-1 at Seattle's Boeing Field. Brennan used the big aircraft for charters and sightseeing flights around Western Washington in the mid-1930s. (TMOF.)

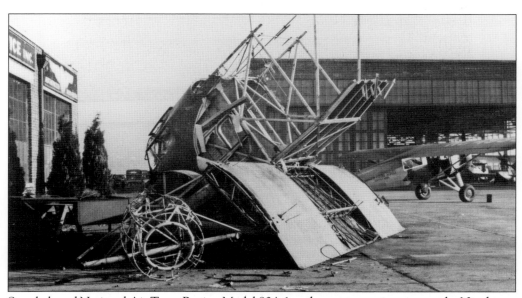

Seattle-based National Air Tours Boeing Model 80A-1 undergoes scrapping next to the Northwest Air Service hangar at Boeing Field. In 1929, Boeing listed a standard 80A-1 at $75,000. By the mid-1930s, more modern airliners had replaced the Model 80s. The sole surviving Model 80A-1 can be seen in Seattle's Museum of Flight's Great Gallery. (TMOF.)

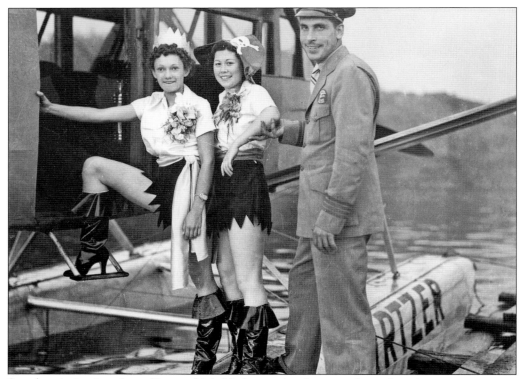

Seattle aviation icon Lana Kurtzer (right) helps two local women dressed in pirate costumes into one of his Travel Air 6000s at his south Lake Union headquarters. A local community festival might have prompted the use of the costumes. Kurtzer operated several Travel Air 6000s in the 1930s and 1940s. (TMOF.)

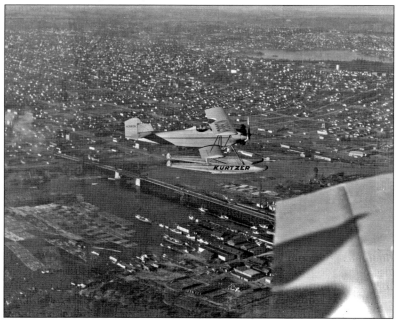

Lana Kurtzer pilots one of his Fleet 7 floatplanes, with its 125-horsepower Kinner B engine, over northwest Seattle in the late 1930s. In the distance is Green Lake. Reuben Fleet, a native of Montesano, about 80 miles southwest of Seattle, founded Fleet Aircraft's parent company, Consolidated, in 1923 in the east. (TMOF.)

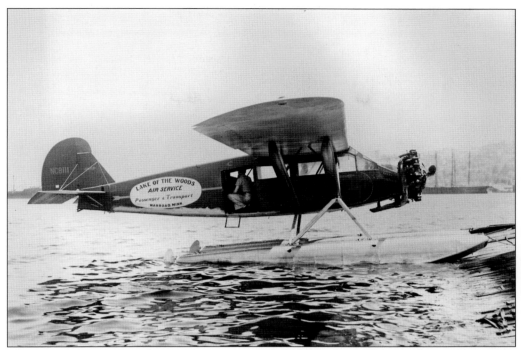

This Travel Air 6000, with a 220-horsepower Wright J5 engine, still bears the markings of its former Minnesota-based owner. After lengthy negotiations, Lana Kurtzer purchased the six-place aircraft, pontoons and skis included, for $3,500 and brought it to Seattle's Lake Union in 1936. The aircraft was originally designed by a team led by Walter Beech in 1928. (TMOF.)

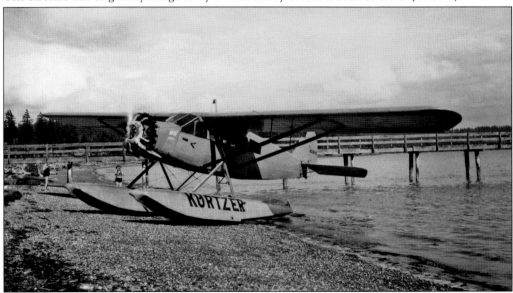

A Kurtzer Flying Service Travel Air 6000 demonstrates one of the practical aspects of seaplane operations in the Pacific Northwest. Puget Sound and the numerous lakes with their accessible beaches, including this one by Lake Washington near Seattle in the late 1930s, have always made seaplanes an attractive regional option. (TMOF.)

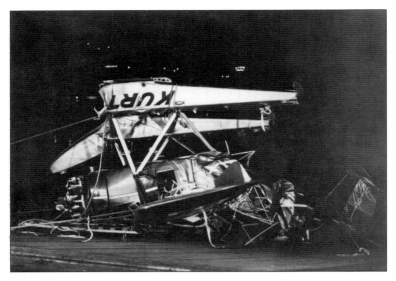

Little is left to salvage after recovering the wreckage of this Seattle-based Kurtzer Flying Service Fairchild 24 in the late 1930s. The four-place Fairchild 24, powered by a 145-horsepower Warner Super Scarab engine, proved to be a popular choice for charter services and flight schools in the 1930s and 1940s. (TMOF.)

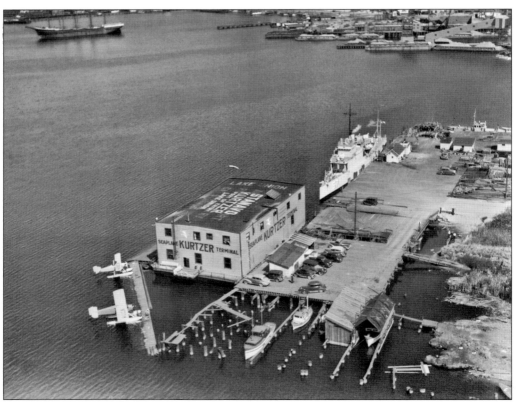

Two aircraft wait at the Kurtzer Flying Service floating hangar on the south end of Seattle's Lake Union. Vern Gorst moved the hangar from Pier 3 on the Elliott Bay waterfront to this location at Valley Street and Fairview Avenue. Kurtzer bought it in the mid-1930s. A fire destroyed the hangar, which had been moved slightly west and north, in 1991. (MOHAI-P.)

Four

ALASKA GATEWAY

In the years immediately following World War I, entrepreneurs in Seattle and Alaska expressed interest in establishing an aviation link between the Pacific Northwest and the Last Frontier. The virtual absence of adequate airfields and the insufficient range of the relatively primitive aircraft available in the early 1920s, however, would make regular service impossible for many years.

Alaska-Washington Airways' limited success in the late 1920s and early 1930s demonstrated that the technology was available if the money was. And that was the problem as the Great Depression curtailed grandiose plans. Nevertheless, the difficult economy prompted numerous experienced aviators from Seattle and elsewhere to head north where the airplane was becoming increasingly essential to the economic growth of Alaska.

As these small operators flourished, they depended on Seattle for maintenance and logistical support. Most aircraft operating in coastal Alaska in the 1930s either transited Seattle on their way north or returned to the Emerald City for maintenance checks. Aircraft operating out of the interior also would call on Seattle. Thus, Lake Union for floatplanes and Boeing Field for land planes would frequently host Alaska-based aircraft. Bryn Mawr, now the site of Renton Municipal Airport, proved popular for operators wishing to convert their aircraft from floats to wheels or vice versa because it could accommodate both types of airplanes. Ultimately, Pan American Airways, with its Pacific Alaska Airways subsidiary, would become the most visible Alaska operator in Seattle before the United States entered World War II in December 1941.

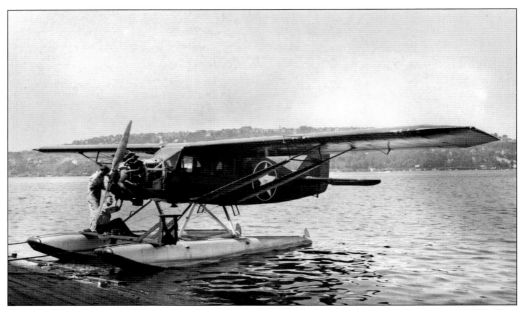

Steve Mills, who moved from Seattle to Anchorage to help start Star Air Service in 1932, flew this Bellanca CH-300 Pacemaker to Lake Union in the first direct passenger flight between the two cities in June 1934. Mills learned to fly from Elliott Merrill at Boeing Field, then instructed for Merrill. Mills died in a crash in 1936. (TMOF.)

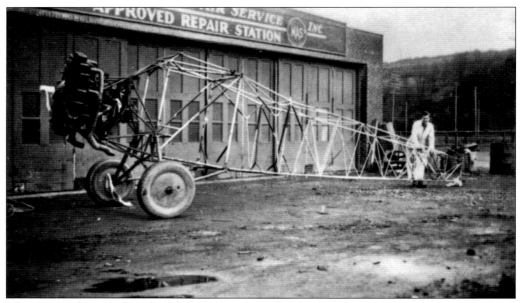

Like many other Alaska pilots, Bob Reeves depended on Seattle for his maintenance needs. A Northwest Air Service mechanic stands next to the airframe of Reeves's Fairchild 71 at Boeing Field in the early 1930s. The Fairchild 71 proved to be well suited to the demands of flying in Alaska. (TMOF.)

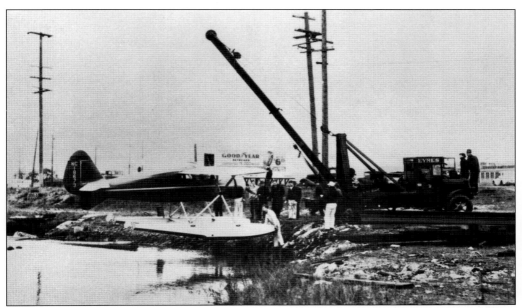

In the Seattle area, the easiest place for aircraft to transition between floats and wheels was Bryn Mawr in Renton. However, sometimes other means were required, as in the case here where an Alaska Coastal Fairchild 24 is being lowered into the Duwamish River near Boeing Field. Marine Airways and Alaska Air Transport merged in 1939 to form Alaska Coastal. (TMOF.)

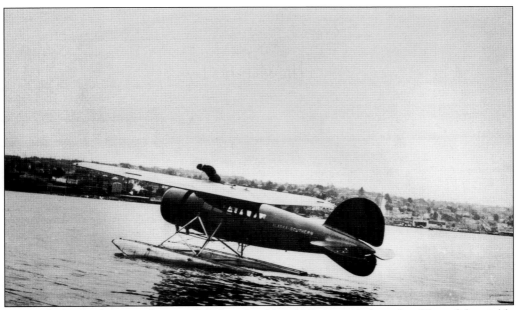

After Alaska-Washington Airways failed, its Lockheed Vegas, including this 5B model, quickly found a new home with Ketchikan-based Alaska Southern. Alaska Southern founder Nick Bez sold out to Pacific Alaska Airways, a Pan American subsidiary, in 1934. After World War II, Bez founded Seattle-based West Coast Airlines. (TMOF.)

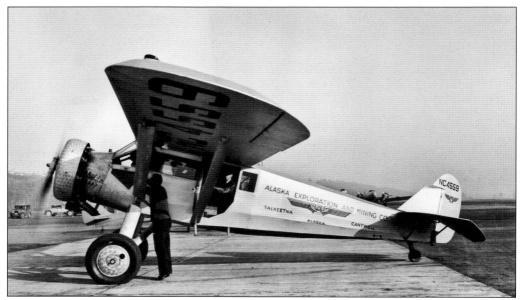

Besides serving isolated communities with freight and passenger service, small aircraft assisted canneries and mines. In the spring of 1934, pilot Roy Dickson sits in the door of this Ryan B.1 Brougham, with its 225-horsepower Wright J5 engine, at Seattle's Boeing Field before taking it to Alaska for the summer. Bowman Airways later operated the aircraft in Alaska. (TMOF.)

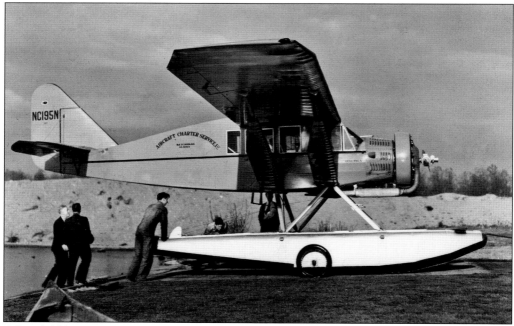

After dabbling in the auto industry through much of the 1920s, Herb Munter returned to commercial aviation in the 1930s when he operated this Bellanca CH-300 Pacemaker as Aircraft Charter Service out of Ketchikan. Munter (far left) observes mechanics as they haul his aircraft out of Lake Washington at Bryn Mawr, southeast of Seattle. Munter helped Nick Bez start West Coast Airlines after World War II. (TMOF.)

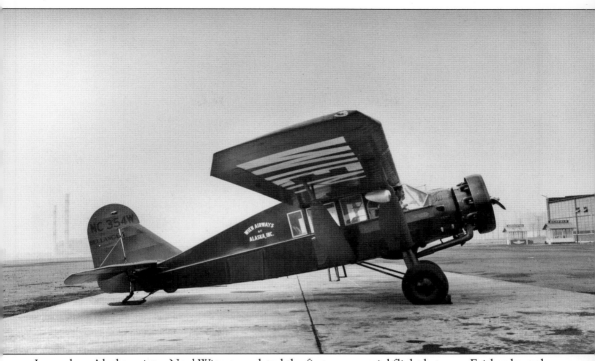

Legendary Alaska aviator Noel Wien completed the first commercial flight between Fairbanks and Seattle's Boeing Field in August 1935 in this Bellanca Pacemaker powered by a 300-horsepower Pratt and Whitey R-985 Wasp Junior. Wien flew all night as he raced a Pacific Alaska Airways (PAA) crew to Seattle with the first photographs of the tragic crash of record-setting flyer Wiley Post and radio celebrity Will Rogers near Point Barrow. Though Wien's aircraft was considerably slower than the PAA Lockheed Vega, he started earlier and he flew a more direct route over the dangerous mountains of central British Columbia into Seattle. The PAA aircraft took the longer coastal route. (TMOF.)

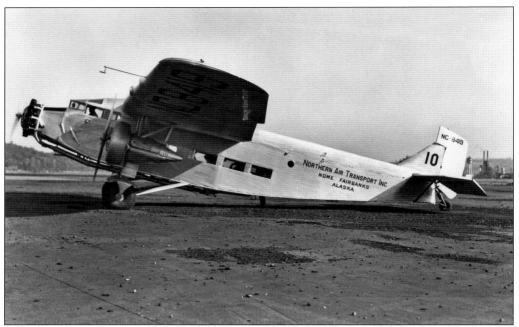

With the $3,500 earned by flying the Rogers-Post crash film to Seattle, Noel Wien and associate Vic Ross purchased this former Northwest Airlines Ford 5-AT-C in August 1935. Shortly thereafter, they returned to Fairbanks with the first revenue passengers to fly directly between Seattle and interior Alaska. For a brief time, Wien's airline was known as Northern Air Transport. (TMOF.)

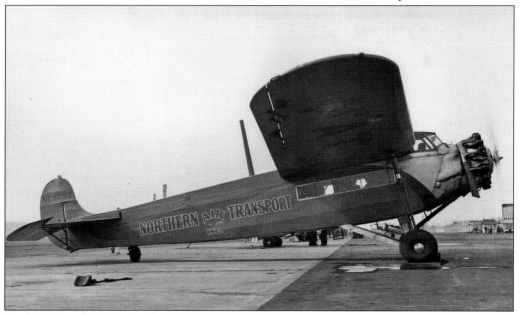

Noel Wien and Vic Ross added this Fokker Super Universal, shown here at Seattle's Boeing Field, to their fleet in 1935. The Super Universal, powered by a 420-horsepower Pratt and Whitney Wasp engine, carried six passengers and a crew of two. In North America, Fokker built more Super Universals than any of its other types. (TMOF.)

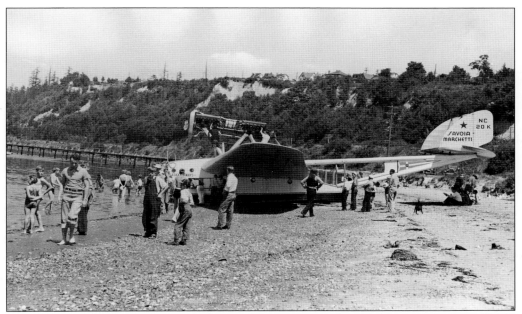

In the summer of 1936, curious onlookers gather to inspect a beached Savoia-Marchetti SM-55 of Alaska Airways at Golden Gardens Park in northwest Seattle. Originally designed as a naval-attack aircraft, the flying boat featured two catamaran-type separate hulls with the cockpit in the leading edge of the wing. (TMOF.)

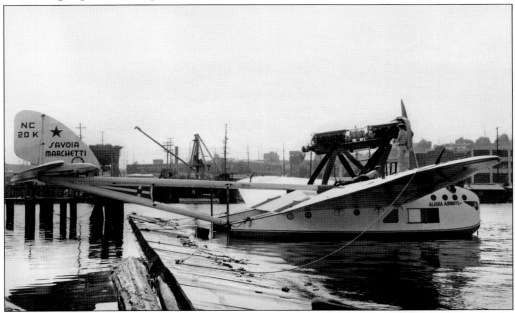

At Seattle's Lake Union, mechanics labor over the two 700-horsepower Fiat A-24R 12-cylinder engines that powered the Savoia-Marchetti SM-55. Tony Schwamm created Alaska Airways with the intent of operating two SM-55s. Unfortunately, the aircraft proved unsuitable for operations in Alaska. One was cannibalized for parts; the other was damaged beyond repair in a storm. (TMOF.)

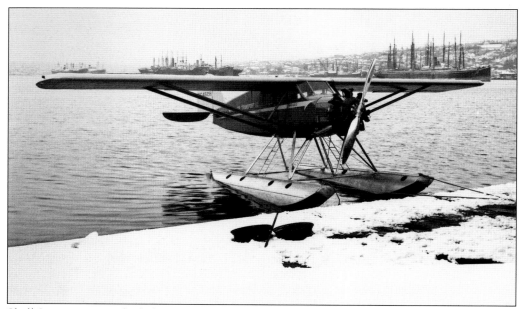

Shell Simmons started Alaska Air Transport in Juneau in 1935 with this Stinson SM-2AC Junior, shown here during a harsh Seattle winter at the south end of Lake Union. A 225-horsepower Wright J6-7 Whirlwind engine powered the SM-2AC. This particular aircraft was known as *PATCO* since it once belonged to Panhandle Air Transport. (TMOF.)

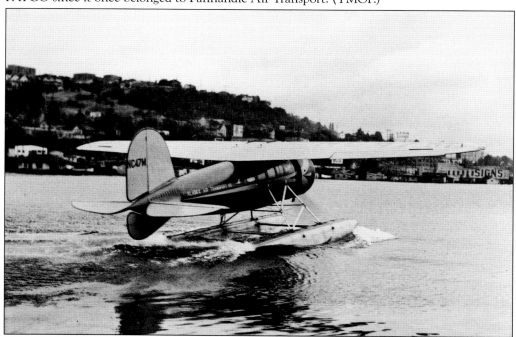

An Alaska Air Transport Lockheed Vega 5C taxis northward on Seattle's Lake Union with the west shoreline in the background. Shell Simmons bought this aircraft, powered by a 450-horsepower Pratt and Whitney Wasp engine, from Wilbur Irving. Irving briefly operated it in Alaska after Air Express flew it as part of a coast-to-coast parcel service. (TMOF.)

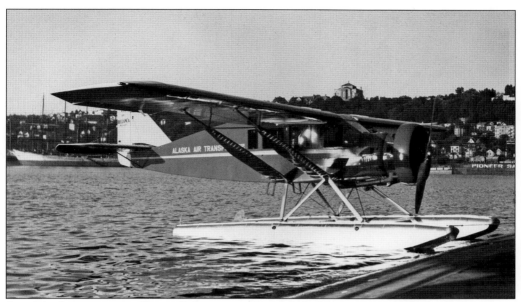

Seattle's afternoon sun reflects off the waters of south Lake Union onto an Alaska Air Transport Bellanca CH-400 Skyrocket. The principal difference between the CH-400 and its predecessor, the CH-300 Pacemaker, was the increased power delivered by the more robust 420-horsepower Pratt and Whitney Wasp engine. The six-place Skyrocket was noted for its shorter takeoffs and exceptional climbing ability. (TMOF.)

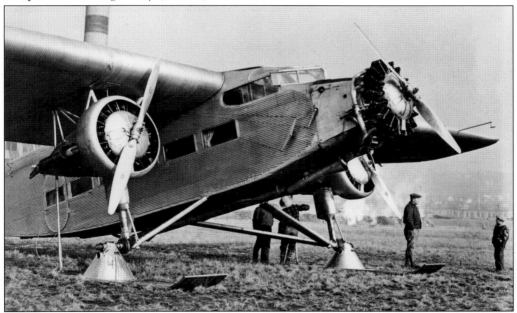

In January 1937, this Arctic Airways Ford 5-AT-C Tri-Motor awaits wheels at Seattle's Boeing Field. Pilot Chet Browne departed Anchorage intending to replace the skis with wheels in British Columbia. Learning Seattle had four inches of snow, Browne continued. By his arrival, the snow had melted, so Browne deftly landed the aircraft on some wet grass at the field's north end, just missing two fire hydrants in the process. (TMOF.)

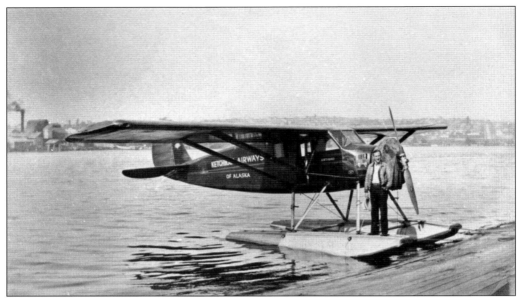

Pilot Chet McLean stands on the pontoon of Ketchikan Airways' Stinson SM-8A Junior at Seattle's Lake Union Air Terminal. Jim Hickey started Ketchikan Airways in the early 1930s when he brought this aircraft, known as the *Northbird*, to Alaska. Introduced in 1930, the SM-8A with its new 210-horsepower Lycoming engine immediately dominated the marketplace. (TMOF.)

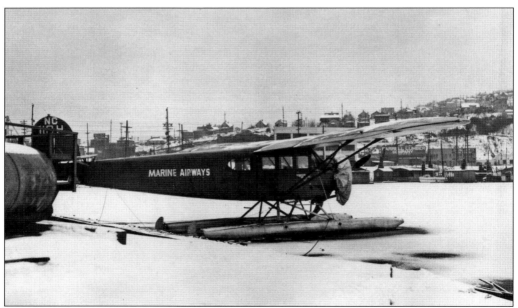

A Marine Airways Fairchild 71 sits at the south end of an iced-over Lake Union. In 1936, Alex Holden started Marine Airways out of Juneau, Alaska. Before that, he operated a flying school and briefly worked for Pacific Air Transport in Tacoma and then flew for Seattle-based Alaska-Washington Airways and other carriers. (TMOF.)

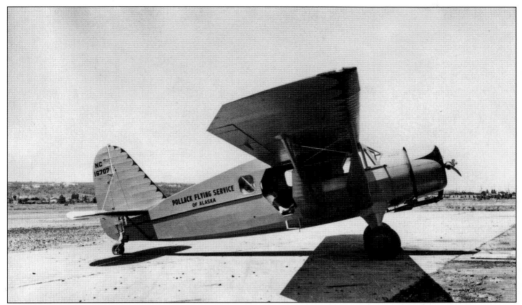

Throughout the 1930s, Bellanca's sales dropped. To revive interest, the company produced the 31-42 Senior Pacemaker featuring a 420-horsepower Wright R-975-E2 engine. Despite improvements, only five or six were sold, including this one, shown here at Seattle's Boeing Field, to Pollack Air Service of Fairbanks. (TMOF.)

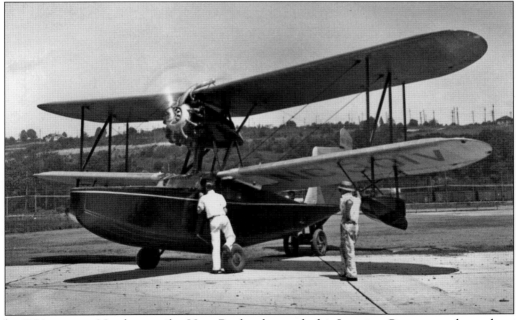

In 1934, veteran Northwest pilot Vern Bookwalter took this Loening Commuter, shown here at Seattle's Boeing Field, to Alaska to enable the White Pass and Skagway Railway to operate airline service between the two communities. Bookwalter worked briefly for Vern Gorst and later flew for Mamer Air Transport out of Spokane. A 300-horsepower Wright J6 powered the commuter. (TMOF.)

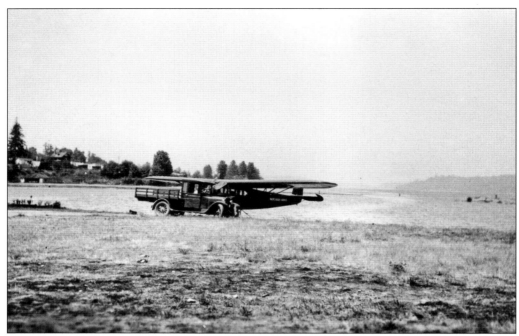

As early as 1926, Pan American Airways (Pan Am) founder Juan Trippe recognized Alaska's potential for his airline. In June 1932, he founded Fairbanks-based subsidiary Pacific Alaska Airways, which initially standardized its fleet around the Fairchild 71, one of which waits at Bryn Mawr southeast of Seattle at the south end of Lake Washington. (TMOF.)

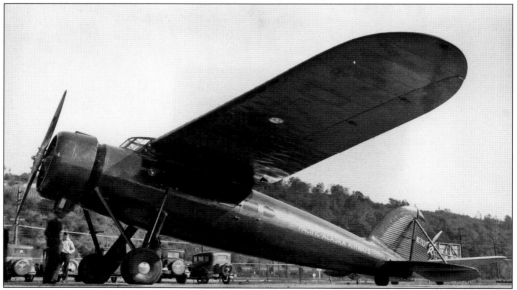

In 1933, Pacific Alaska expanded its fleet to include three Consolidated Fleetsters, including NC703Y (shown here at Seattle's Boeing Field), originally owned by Ludington Airlines. Pan Am converted it to a 17AF by installing a 575-horsepower Wright R-1820-LC engine. This Fleetster and another were sold to the Soviets to assist in rescuing Russians trapped on a vessel in the Arctic ice. (TMOF.)

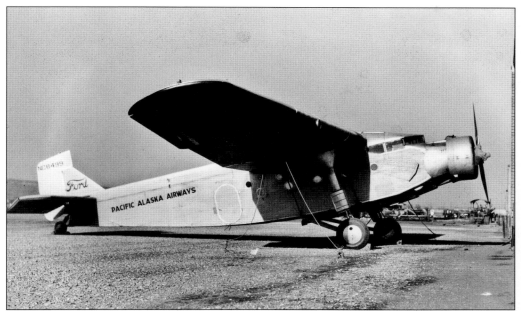

In 1934, Pacific Alaska's Ford 8-AT stops at Seattle's Boeing Field on its way north. Pacific Alaska used Ford's only 8-AT for freight operations. Operating on wheels, floats, or skis, the 8-AT with its single 700-horsepower Wright GR-1820 F1 Cyclone engine proved to be underpowered according to its most frequent pilot, Jerry Jones. (TMOF.)

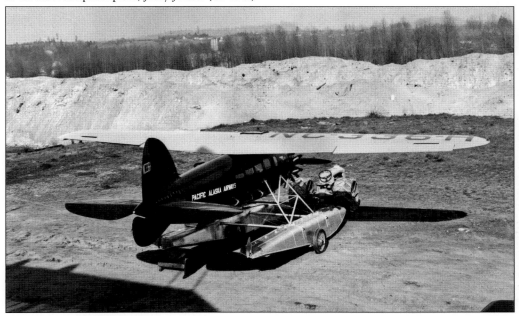

Late in 1934, Pacific Alaska bought Juneau-based Alaska Southern from Nick Bez. The purchase included several Fairchild 71s and Lockheed Vegas. The most attractive feature of Bryn Mawr, southeast of Seattle on Lake Washington in Renton, was the opportunity to easily transition aircraft between wheels and floats. In April 1935, the tractor moved this Vega between the hangar and seaplane ramp. (TMOF.)

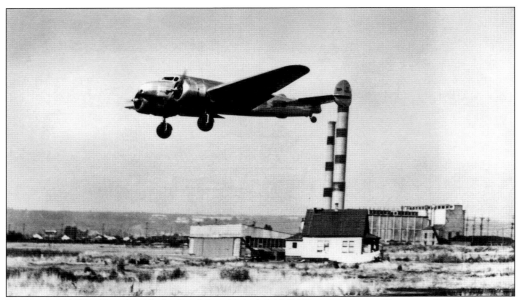

In August 1935, a Pacific Alaska Lockheed Model 10-E Electra, powered by twin 550-horsepower Pratt and Whitney Wasp engines, arrives at Seattle's Boeing Field from Alaska with the bodies of Wiley Post and Will Rogers. Joe Crosson with Bob Gleason made the flight from Fairbanks after picking up the bodies near Point Barrow in a Fairchild 71. (TMOF.)

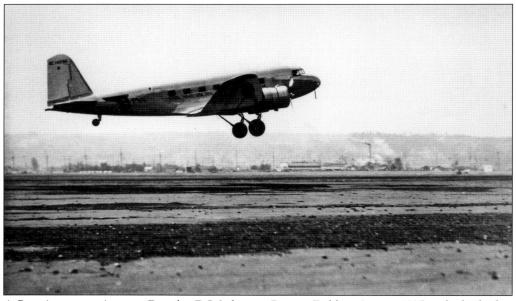

A Pan American Airways Douglas DC-2 departs Boeing Field in August 1935 with the bodies of Wiley Post and Will Rogers. Pan Am founder Juan Trippe insisted their remains be returned to their families as expeditiously as possible. Pilot Bill Winston flew the DC-2 from Pan Am's Brownsville, Texas, base to Seattle to pick up the bodies. (EDC.)

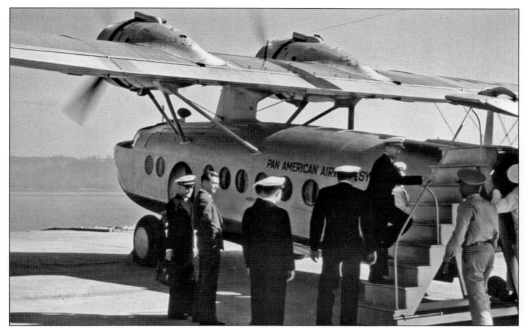

In August 1938, the crew boards a Pan American Sikorsky S-43 "Baby Clipper" at Sand Point, northeast of Seattle, for a survey flight to Juneau via Ketchikan. Pan American operated one round-trip a week for several months from Sand Point before deciding the route was too challenging for the technology then available. (TSC.)

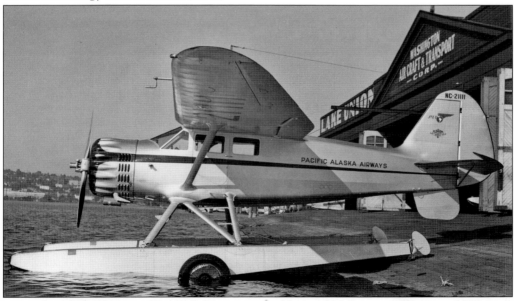

A Pacific Alaska Stinson SR-10F Reliant, powered by a 400-horsepower Pratt and Whitney Wasp Junior SB engine, basks in the sun on the ramp of Seattle's Lake Union Air Terminal. Elliott Merrill's Washington Aircraft and Transport Corporation, headquartered at Boeing Field, purchased the terminal in 1938 after the U.S. government cancelled Percy Barnes's airmail contract to Victoria in 1937. (TMOF.)

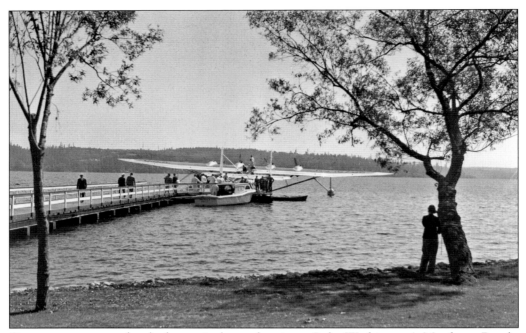

Crew, passengers, and onlookers mingle on the pier at Lake Washington's Matthews Beach, northeast of Seattle, before a Pan American Airways Sikorsky S-42B Clipper departs for Ketchikan and Juneau. Pan Am only operated the S-42B on this run between June and October 1940. The aircraft later served in the Far East. Japanese bombers destroyed it in Hong Kong on December 8, 1941. (MOHAI-PI.)

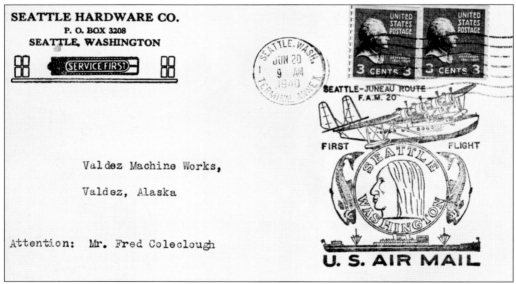

This cover commemorates Pacific Alaska Airways' inauguration of Foreign Air Mail Contract 22 with service between Seattle and Juneau, which began on June 20, 1940. After determining the Sikorsky S-43 was unsuitable for this route, Pan American Airways transferred the *Bermuda Clipper*, a larger Sikorsky S-42B, to the run. In October, Pan American halted the service and sent the aircraft back to Bermuda. (EDC.)

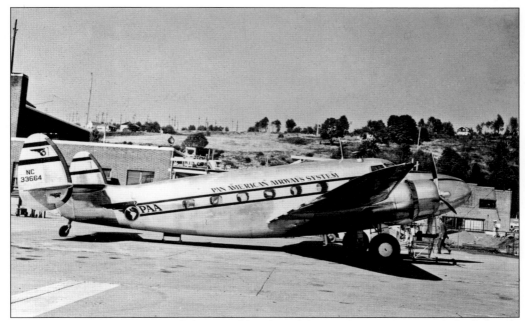

Pacific Alaska Airways operated three Lockheed Model 18 Lodestars, the first of which is seen here at Boeing Field in the spring of 1941. The airline flew four weekly round-trips between Seattle, Juneau, Whitehorse, and Fairbanks. In May, Pacific Alaska became the Alaska Division of Pan American Airways. (TMOF.)

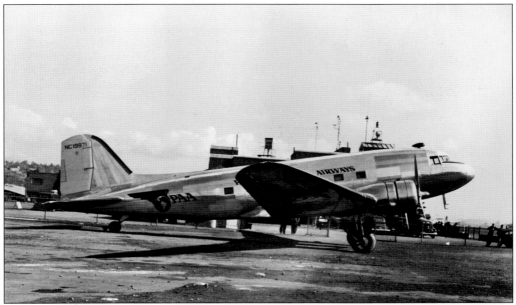

By the late 1930s, Pan American Airways' fleet included several dozen Douglas DC-3s, including this one at Seattle's Boeing Field in late 1940. Pan American used this DC-3 and then another to augment its Seattle-Juneau service that relied primarily on Lockheed Model 18 Lodestars. The introduction of improved landing fields in central British Columbia convinced Pan Am to use faster land planes on the inland route. (TMOF.)

Unable to secure a mail contract along the Alaska panhandle, Pacific Alaska halted its southeast operation in 1935 in favor of focusing on the interior with its operations base in Fairbanks. By late 1941, when this timetable was published, Pan Am had absorbed Pacific Alaska and renamed its operation there the Alaska Division. One-way service on a Lockheed Model 18 Lodestar or Douglas DC-3 between Seattle and Fairbanks with a stop in Juneau cost $170. After the United States entered World War II in December 1941, military necessities limited civilian operations. Pan American, United, and Northwest all played significant roles as contract carriers for the U.S. Army Air Forces' Air Transport Command, moving essential supplies and personnel to and from Alaska during the war. (EDC.)

Five

BOEING AIRPLANE COMPANY, SEATTLE'S PLANE MAKER FOR THE WORLD

William Boeing, together with Joseph Foley and Ed Gott, incorporated the Pacific Aero Products Company in the state of Washington on July 15, 1916. The plans for the new corporation were all encompassing, though the wording in the first paragraph stated that the business was formed "to engage in a general manufacturing business and to manufacture goods, wares and merchandise of every kind, especially to manufacture aeroplanes and vehicles of aviation." On April 26, 1917, the name was changed to the Boeing Airplane Company.

The first factory was a shipyard on the marshy flats on the west side of the Duwamish River, 2 miles or so downstream from Boeing Field. The shipyard's original owner, Edward Heath, building a yacht for William Boeing, supposedly faced bankruptcy. In 1910, he sold the whole business to his client. William Boeing moved his fledgling airplane manufacturing there in 1916, when it was known as the Oxbow plant. In the 1930s, the expanding Boeing Airplane Company built a new assembly plant upstream on the east side of the river, known as Plant 2, and the Oxbow was renamed Plant 1.

The first commercial success built in quantity over a number of years was the Model 40 family of mail and passenger planes, the majority of which were delivered to the Boeing Group's own airlines. The similar Model 95 mail planes followed. In July 1928, the Model 80, a 12-passenger "Pullman of the skies," made its first flight from Boeing Field. The all-metal, experimental Monomail, only two of which were built, led to the Model 247, often referred to as the "first modern airliner."

Finally, in the period covered by this book, came the iconic Model 314 Clipper flying boat and the Model 307 Stratoliner, America's first four-engine pressurized passenger airliner. Both were only built in small quantities as Boeing's production lines changed to meet the nation's need for B-17 Flying Fortress bombers.

William Boeing was born in Detroit, Michigan, on October 1, 1881, and attended Yale University. In 1903, he moved to the Grays Harbor area in southwest Washington, where he engaged in the timber business. Relocating to Seattle, he became interested in the fledgling world of aviation, and in 1914, he founded the Northwest Aero Club to further focus the members' interests and aspirations toward aviation. In a hangar built on the east side of Lake Union, the first Boeing planes were assembled. The Boeing Airplane Company moved to the Oxbow plant, and the company won its first military contract. The first civil airliners were built in 1927, the beginning of a period of incredible growth into a conglomerate that controlled almost every aspect of aircraft design, building, and operation. Disillusioned by a bitter U.S. Senate investigation, William Boeing divested himself of control and operation of the company in 1934. He died in 1956, but the Boeing name remains on the masthead of America's premier aircraft builder. (EDC.)

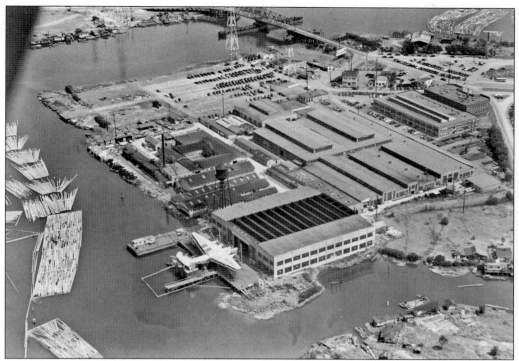

This June 1941 aerial view shows Boeing's Oxbow plant on the mudflats of the west side of the Duwamish River. The aircraft on the outside of the assembly building is the *Capetown Clipper*, last of the Model 314 flying boats built for Pan American Airways. The building to the left of the plane is the Red Barn, now part of Seattle's Museum of Flight. (BA.)

In November 1936, crews moved into the first phase of the new B-17 assembly building, erected alongside Boeing Field. In August the following year, two bays were added to what was then called "Plant 2" to accommodate the assembly of the Stratoliner, three of which are shown in various stages of construction. (TMOF.)

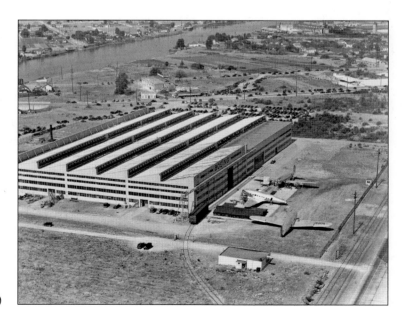

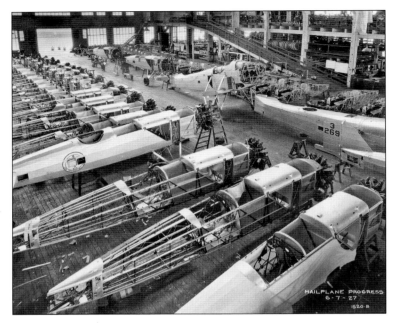

This 1927 photograph shows the production line at the Oxbow plant where 25 of Boeing's Model 40A mail and passenger planes are being assembled for Boeing Air Transport. Immediately behind the engine are a mail compartment, then the enclosed two-place passenger cabin, another mail pit, and then the pilot's open cockpit. The welded steel and wood structure aft of the passenger cabin is fabric covered. (BA.)

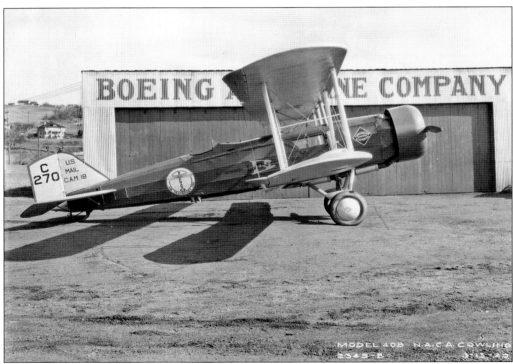

Boeing converted its Model 40 mail planes, such as this one at Boeing Field in March 1929, from A to B models by replacing the 425-horsepower Pratt and Whitney Wasp engine with the 525-horsepower Hornet. The CAM 18 on the tail indicates the aircraft was to be used by Boeing Air Transport on the Oakland-to-Chicago route. (BA.)

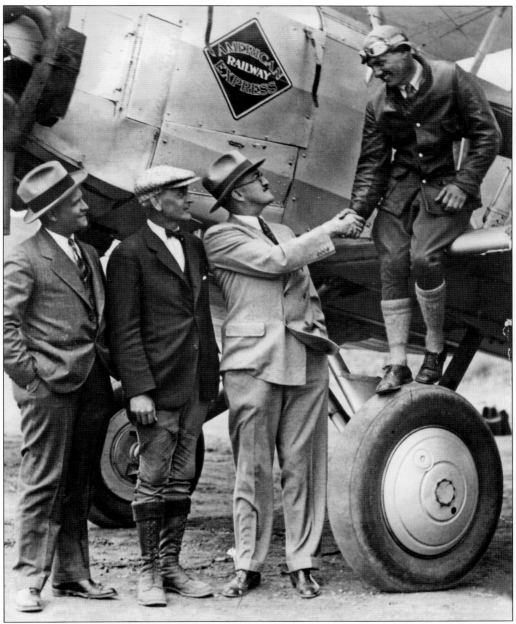

William Boeing congratulates pilot Grant Donaldson in July 1928 at Boeing Field prior to the delivery flight of Pacific Air Transport's Boeing Model 40C, registered C-6841. Donaldson later flew the plane to Portland's Swan Island Airport. On the left is Philip Johnson, general manager of the Boeing Airplane Company and president of both Boeing Air Transport and Pacific Air Transport. To Johnson's right is Jules V. Hyde, Boeing field's first manager. The insignia on the plane above Boeing's head is that of the American Railway Express Company, whose trucks delivered express packages to the departing planes and picked them up at the destination airport, delivering them directly to the consignee's address. Two months later, pilot Donaldson suffered serious burns when he crashed in a similar plane near Canyonville, Oregon. (BA.)

Addison Pemberton acquired the remains of Grant Donaldson's crashed Boeing 40C in 1999. He and his crew, based at Felts Field in Spokane, began a painstaking nine-year restoration that resulted in the plane being returned to pristine flying condition. The June 2008 photograph shows the plane taxiing out for a flight at Boeing Field. (ED.)

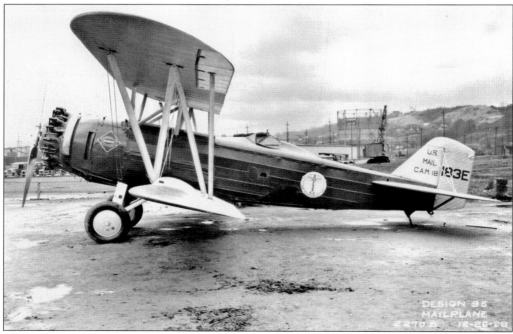

This December 1928 photograph at Boeing Field shows the Boeing Model 95, similar to the 40B. However, the passenger cabin has been eliminated in favor of only a mail compartment. Aerodynamic improvements enhanced its cruising speed compared to the 40B. The lower wing is staggered back to give the pilot improved ground visibility on landing. (BA.)

An early Boeing Model 80 goes through final assembly at Plant 1 in July 1928. Kapok soundproofing insulation has been installed over the cabin's wooden frame within the fuselage metal tube diagonal bracing. Aft of the passenger cabin, the structure is wire braced. Later some of the 40 or so women who worked at the factory would install and sew the fuselage and wing fabric covering. (TMOF.)

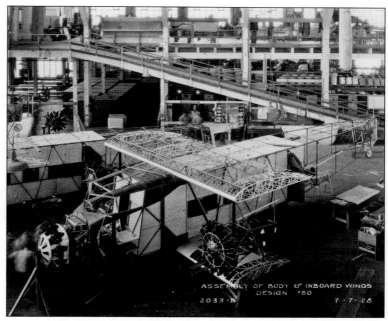

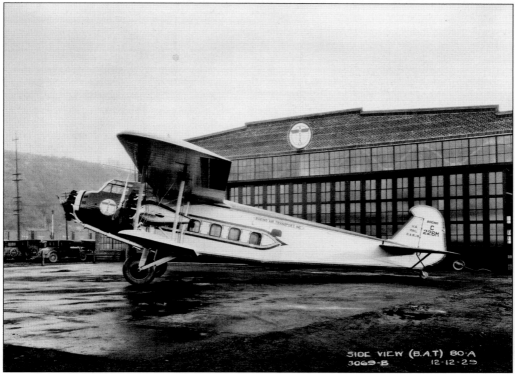

The larger Boeing Model 80A is shown at Boeing Field on December 12, 1929, the day of its 18-minute first flight. This plane entered scheduled passenger service with Boeing Air Transport a week later, flying passengers and mail between Oakland, California, and Salt Lake City, Utah. Later in its career, it was modified with a triple tail. (BA.)

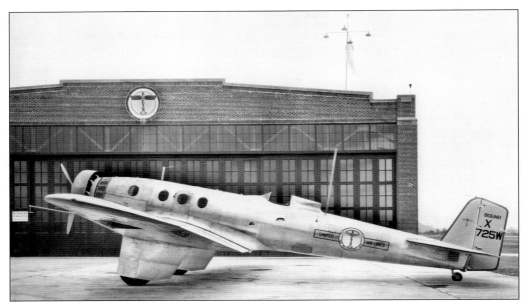

Boeing built two Monomails as experimental transitional aircraft between the fabric-covered biplanes and the first of the multiengine all-metal airliners. X725W is shown at Boeing Field in 1931 after conversion to an eight-passenger Model 221A with fixed gear and streamlined wheel pants. The pilot remains in the traditional open cockpit, with limited landing visibility. (BA.)

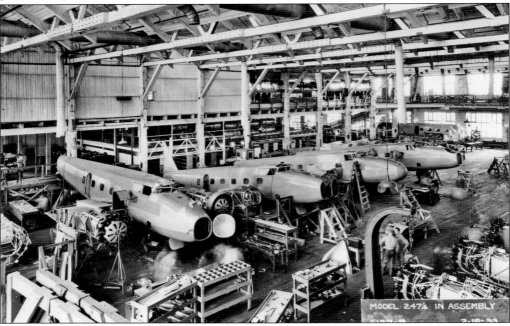

This February 1933 photograph shows Boeing Model 247s being assembled at Plant 1, after which they were barged across the Duwamish River to Boeing Field for final assembly and flight-testing. This fast, all-metal passenger aircraft has often been described as the "first modern airliner." Innovations included retractable main landing gear but no pressurization. Note the cargo-bay door in the nose. (BA.)

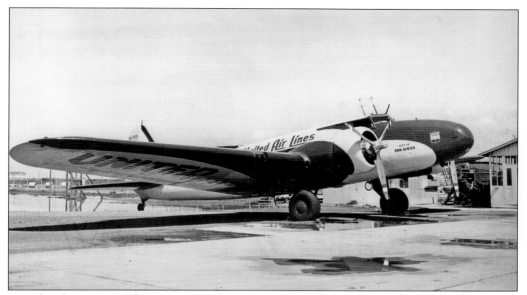

For a brief time, United Air Lines used the streamlined blue and white finish as seen here on a Boeing 247D at Boeing Field in 1941. Note the distinctive forward-sloping windshield. This particular 247 later served with several other airlines and the U.S. Army Air Force. Bought by TWA, it was wrecked in a landing accident at Allegheny City (Pennsylvania) Airport in November 1942. (WLC.)

One of the distinctive features of the Boeing 247 airliner was the wing spars running through the cabin. In this photograph looking forward toward the enclosed two-pilot cockpit, it is clear the steps in the narrow aisle pose an uncomfortable hazard for the stewardess. The steps were necessary to cross over the front and rear wing spars. (EDC.)

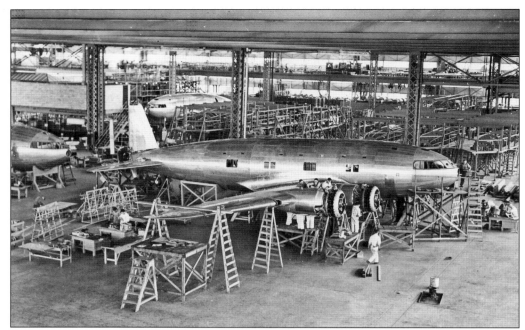

Model 307 Stratoliners proceed through the assembly process in Boeing's Plant 2, situated across East Marginal Way on the west side of Boeing Field. The 307s were the first pressurized aircraft designed and built in the United States to enter airline service. They ushered in a new level of comfort for the flying public. The prototype crashed near Alder, Washington, while on a demonstration flight. (EDC.)

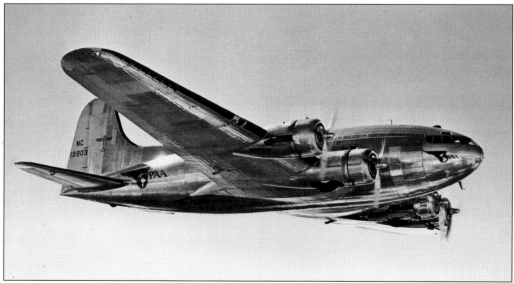

This predelivery, in-flight photograph shows one of Pan American Airways' Model 307s, *Clipper Flying Cloud*. Only 10 Stratoliners were built, all before World War II. Then the urgent requirement for bombers curtailed the production of civil airliners. During the war, the TWA 307s were turned over to the U.S. Army Air Transport Command, returning briefly to the airline's transcontinental routes in 1945. (EDC.)

This interior photograph of one of the 307B Stratoliners delivered to TWA shows one of the six-seat compartments, each of which could be converted to four berths for night flying. Down the left-hand side was a single row of nine reclining seats. Marshall Fields of Chicago supplied furnishings for all the TWA planes. (EDC.)

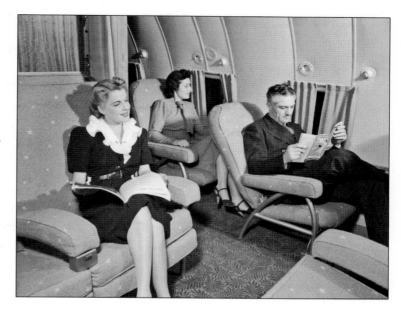

On June 23, 2001, the refurbished *Clipper Flying Cloud* is rolled out of the Boeing Plant 2 hangar, where it was originally assembled more than 60 years earlier. This aircraft later suffered a water landing in nearby Elliott Bay, was again refurbished, and was then flown to Washington, D.C., for display in the Udvar-Hazy Center of the Smithsonian's National Air and Space Museum. (ED.)

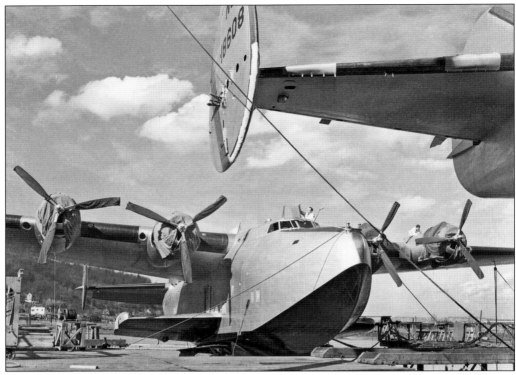

Two Boeing 314A Clippers from the second production batch are photographed during the spring of 1941 on the ramp at Plant 1. There was insufficient room to complete the flying boats inside the assembly building; the outer wing panels, engines, and empennage were fitted out on the ramp. Both these aircraft, *Bristol* and *Berwick,* were delivered to the British Overseas Airways Corporation. (BA.)

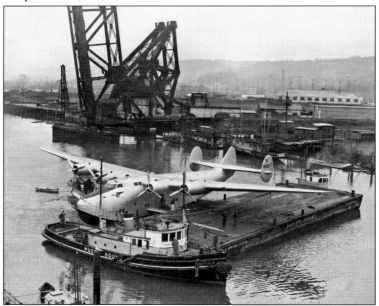

The second of the 12 Boeing 314 Clippers is towed down the Duwamish River from the Oxbow plant to Elliott Bay for its January 1939 first flight. Registered NX18602 for the test flights and later christened *California Clipper,* it was delivered to Pan Am and flew the first 314 proving flight across the Pacific to Hong Kong. (BA.)

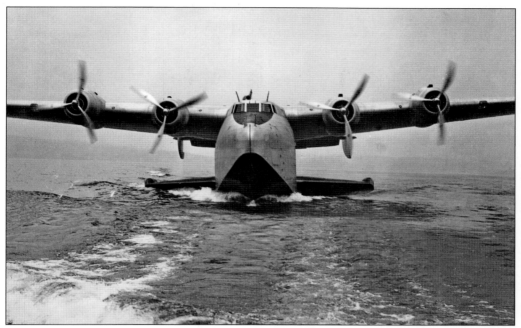

In this dramatic photograph, one of the huge Boeing 314 flying boats taxis behind a picket boat on Puget Sound. The lower sea wings provide stability on the water, hold considerable quantities of fuel, serve as a boarding platform for crew members and passengers, and replace conventional wingtip floats. (EDC.)

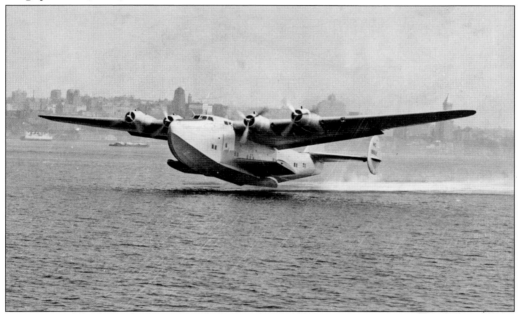

The last of the Boeing 314 flying boats takes off from the waters of Elliott Bay in July 1941. In the background is the Seattle waterfront with the Smith Tower on the right. Named *Capetown Clipper* by Pan American Airways, this aircraft was sold to the U.S. Army Air Forces soon after the December 1941 Japanese attack on Pearl Harbor. (EDC.)

www.arcadiapublishing.com

Discover books about the town where you grew up, the cities where your friends and families live, the town where your parents met, or even that retirement spot you've been dreaming about. Our Web site provides history lovers with exclusive deals, advanced notification about new titles, e-mail alerts of author events, and much more.

MADE IN THE USA

Arcadia Publishing, the leading local history publisher in the United States, is committed to making history accessible and meaningful through publishing books that celebrate and preserve the heritage of America's people and places. Consistent with our mission to preserve history on a local level, this book was printed in South Carolina on American-made paper and manufactured entirely in the United States.

This book carries the accredited Forest Stewardship Council (FSC) label and is printed on 100 percent FSC-certified paper. Products carrying the FSC label are independently certified to assure consumers that they come from forests that are managed to meet the social, economic, and ecological needs of present and future generations.

FSC
Mixed Sources
Product group from well-managed
forests and other controlled sources

Cert no. SW-COC-001530
www.fsc.org
© 1996 Forest Stewardship Council

Find Your Place in History.